TONAL VALUES

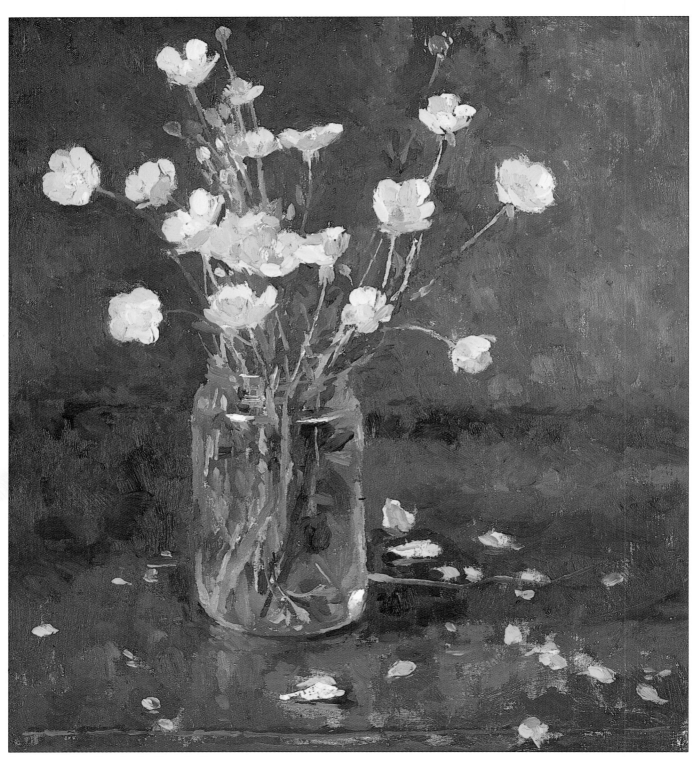

Buttercups in a Jam Jar by Pamela Kay

TONAL VALUES

HOW TO SEE THEM, HOW TO PAINT THEM

ANGELA GAIR

NORTH LIGHT BOOKS

Cincinnati, Ohio

A QUARTO BOOK

Copyright © 1987 Quarto Publishing plc
First published in the U.S.A. by
North Light Books, an imprint of
F & W Publications, Inc
1507 Dana Avenue
Cincinnati, Ohio 45207

First paperback edition reprinted 1992

Library of Congress Catalog Card No:
Gair, Angela, 1954-
 Tonal Values
 Includes index.
 1. Painting — Technique. I. Title.
ND1500.G33 1987 750'.1'8 87-16169

ISBN 0-89134-399-7

This book was designed and produced by
Quarto Publishing plc
The Old Brewery, 6 Blundell Street
London N7 9BH

Senior Editor: Maria Pal
Art Editor: Hazel Edington

Editors: Hazel Harrison and Ricki Ostrov
Designer: Hugh Schermuly

Photographers: Rose Jones and Joy Gregory

Art Director: Moira Clinch
Editorial Director: Carolyn King

Special thanks to Laurence Wood

Typeset by Burbeck Associates and Comproom
Limited
Manufactured in Hong Kong by Regent Publishing
Services Ltd

Printed by Leefung-Asco Printers Ltd, Hong Kong

CONTENTS

INTRODUCTION

When I mentioned to an artist friend of mine that I was writing a book about tonal values in painting, her response was somewhat surprising. "Oh, good," she said, "at last someone is going to explain to me what tonal values are all about!"

My friend's reaction was typical of many artists I have spoken to since. The word "value" causes a great deal of confusion among painters, both amateur and professional. Some mistake it to mean the brightness or intensity of a color; others think it refers to "paintings done in black and white." This confusion can be partly explained by the fact that values *are* actually quite difficult to discern, except in a monochrome subject, since bright colors, textures, patterns and so on are apt to distract the eye and prevent us from judging the value of a color accurately. But another problem is the general lack of information available to the enquiring artist. To my knowledge, not a single book has ever been written specifically on the subject of tonal values – yet there are literally dozens of books that go into great depth about other aspects of painting such as color, composition, perspective and so on. True, some of these books do touch upon the subject of values, but usually with nothing more than a passing reference that leaves the reader feeling more confused than ever!

The dictionary tells us that in painting, tone is "the general effect of light and shade in a picture." But that is only part of the story. True, contrasts of light and dark convey the way in which light and shadow model form. But in addition, the value pattern – the overall design of the image in terms of light and dark shapes – forms the underlying skeleton that holds a painting together and gives it strength and stability. If the value pattern is weak or unbalanced, then the entire picture will be weak and unbalanced, no matter how carefully rendered or technically competent it may be. In short, tonal values are the foundation of a painting.

And yet, since the eighteenth century, more and more emphasis has been placed on color, and less and less on values. This neglect seems odd to me; every color has a tonal value, therefore surely good color relationships depend on good value relationships? It is significant that many of the world's great colorists – Delacroix, Cézanne, even van Gogh – started out by using somber, almost monochromatic colors and strong contrasts of light and dark in their paintings. There's no doubt that this solid grounding in the use of tonal values stood them in good stead when they later began to explore the expressive and emotional effects of color. There is a popular misconception, for example, that Cézanne used color changes alone to model form and convey spatial depth; the truth is that he was fastidious in his concern to construct an overall harmony of color and value, in which no single note was out of tune with the others.

Of course, no one would deny the important role played by the shapes, lines and colors in a painting – all I'm saying is that values deserve more attention than they often get. This book will, I hope, go some way toward redressing the balance. In the chapters that follow you will discover how to:

◆ Simplify complex painting problems by using a limited tonal range
◆ Recognize the interdependence of the tones and colors in a painting
◆ Model three-dimensional form with light and shade
◆ Create the illusion of depth and space through contrasts of value and color
◆ Orchestrate the light and dark values in a painting to create dynamic compositions
◆ Set up mood and atmosphere by keying your tonal values
◆ Choose the best technique to express what you want your picture to say

Writing an art instruction book is always a hazardous venture because, in attempting to explain the principles involved in painting, it is difficult to avoid giving the impression that there is a right way and a wrong way to do things. In Chapter 6, for example, I shall be discussing the various ways in which tonal values can be used in achieving a balanced composition. However, while the ideas and suggestions put forward are sound in principle, they are in no way intended as being a set formula for producing successful pictures. Every compositional "rule" can be broken – and has been on many occasions. What I am attempting to do here is to offer some starting points from which to set off on your own chosen path toward the expression of your ideas.

This is not a book about "how to paint"; it is essentially about "how to see." For this reason you'll find in each chapter at least one project idea that you can try out for yourself. These projects are based on the principles discussed in the book and are designed, not as a copying exercise or as some kind of test of your ability, but simply as a springboard for the development of your own ideas.

*Angela
Gair*

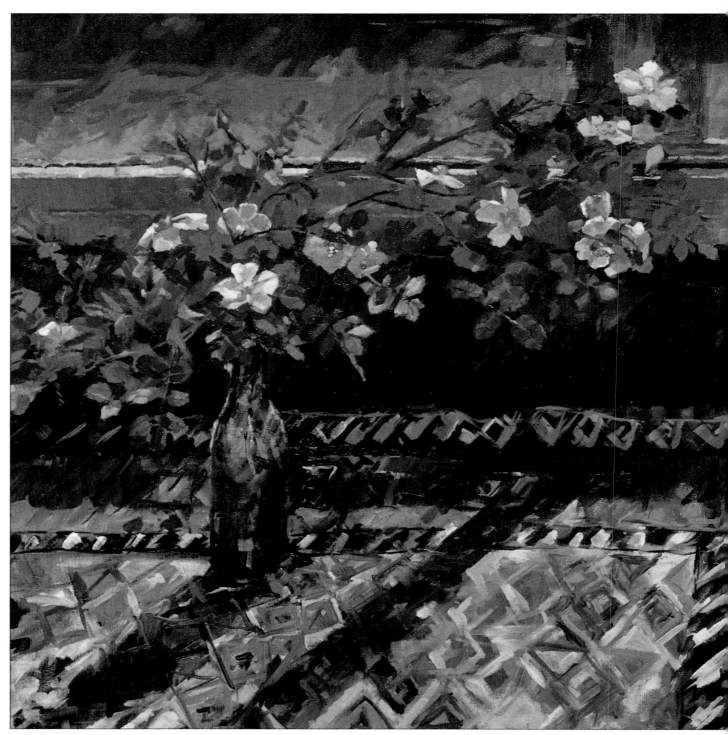

Wild Roses by Jane Corsellis

·1·

THE MAGIC OF LIGHT

An understanding of tonal values is the key to successful painting, because it is through the interplay of values that we are able to reproduce in paint the extraordinary effects of light. Although we do not always realize it, very often when we feel the desire to paint a particular subject, it is not so much the subject itself but the way the light falls on it that inspires us. When light works its magic, creating mysterious shadows, sparkling highlights and subtle reflected lights, it can transform even the most mundane object or place into one of infinite beauty.

Before we begin our study of balancing and arranging values in a painting, you may find it both interesting and instructive to linger over the little "gallery" of paintings that follows on the next few pages. By interleaving the work of past masters with that of painters working today I have tried to show that, though tonal painting has a tradition going back a long way, its principles are just as pertinent today. So take your time, enjoy the paintings, and I hope that they will inspire you in your search for ways to capture the magic of light.

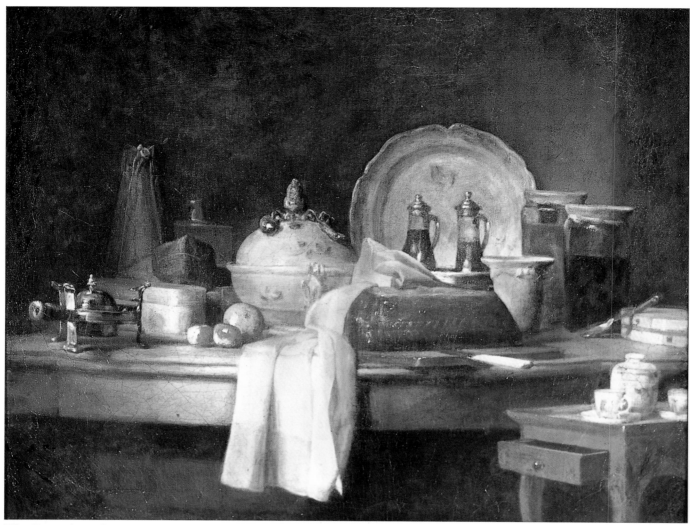

The Remains of a Lunch by Jean-Baptiste-Siméon Chardin (1699-1779), oil on canvas

This photograph *above* of Chardin's still life demonstrates the principle that, in painting, light is produced by sacrifice. The light-struck area in the center takes on greater luminosity because it is surrounded by darker values.

The Remains of a Lunch is one of many still lifes that prompted the art critic Diderot to write, "Oh, Chardin! It is air and light that you take up on the tip of your brush and fix onto the canvas." The lighting comes from in front and to the left, illuminating the plate, the tureen and the white cloth and causing striking areas of light and dark. There is a mistiness in the atmosphere, created by softly gradated tones and the use of scumbles and glazes that give a depth and profundity to the shadows.

In this painting it is clear that Chardin's interest does not lie in detailed representation but in the expression of form and the effects of light on different surfaces. Chardin painted still lifes over 200 years ago, but his style and workmanship, his unerring observation and his integrity of approach are an inspiration to artists even today.

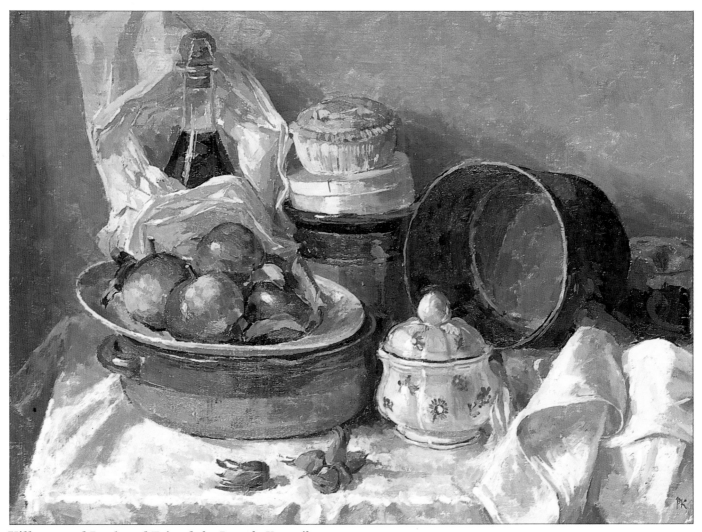

Villeroy and Boch and Friends by Pamela Kay, oil on canvas

Pamela Kay is a contemporary British artist who, like Chardin, delights in depicting aspects of ordinary life. **Villeroy and Boch and Friends** recalls the later still lifes of Chardin, which are composed of the simplest elements, such as kitchen utensils, fruit and vegetables. This composition is simple and seemingly informal, although in fact the objects have been carefully placed so as to form a rhythmic pattern of light and dark. Light falls on the shiny skins of the apples, on the earthenware bowls and on the copper saucepan, emphasizing their roundness and solidity. Notice how few hard edges there are; the artist has applied her paint thickly, melding the objects together by working them wet-in-wet. The colors are muted browns and grays, except for the bright red apples and the white of the drapery, underlying the intimacy and quiet simplicity of the painting.

This detail *above* of the apples in the bowl shows how gradations of tone and contrasts of warm and cool color create a convincing illusion of rounded form. You'll learn more about modeling form in Chapter 4.

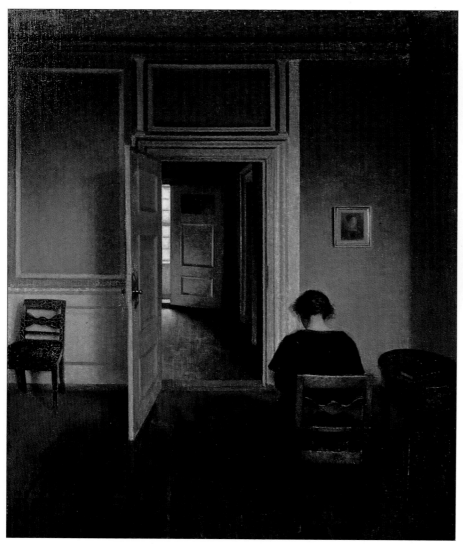

This black and white version of the painting *above* highlights the way the artist has carefully placed light shapes against dark, dark shapes against light, to create a structured rhythm that emphasizes the quiet stillness of the scene. This principle, known as 'counterchange', is discussed in more detail in Chapter 6.

Interior with Seated Woman, 1908 by Vilhelm Hammershøi , oil on canvas

Vilhelm Hammershøi was one of the leading lights of Danish painting during the 1880s. Although his range of subject matter was wide, he is best known for his genre paintings of interiors with solitary female figures, often seen from the back, in which the influence of the Dutch painters De Hooch, Vermeer and ter Borch is evident.

In **Interior with Seated Woman** the figure is sitting before an open doorway that leads onto a darkened hall. Beyond the hall is another open door, through which we glimpse the bright light from a window. The painting has a mood of quiet contemplation, engendered by the sparse, geometric structure of the composition and the harmonious tonality of the colors.

But it is light that is the main theme of the painting.

Cool, subdued daylight glows softly on the dark furniture and accentuates the white painted doorway; it glints off the handle of the door and the picture frame; and it illuminates the woman's bowed head, underlining the softness and vulnerability of her neck. These light-struck areas are beautifully complemented by the subdued mystery of the shadow passages.

In contrast to the smooth patina of Hammershøi's paint surface, Bernard Dunstan uses small flecks and dabs of broken color to build up his forms *above*.

Auberge des Belles Choses by Bernard Dunstan, oil on canvas

Bernard Dunstan is a well-known contemporary painter who firmly believes in the "painterly" approach to painting. In **Auberge des Belles Choses,** he combines the use of broken color, pioneered by the French Impressionists, with the rich tonal values of earlier, more traditional artists. Although this painting is much more relaxed and informal than Hammershøi's brooding, dark interior, there are certain similarities in the structure of the composition. A woman pauses by an open doorway that reveals another, more shadowy room with a small, brightly lit window. As in the Hammershøi painting, gentle gradations of tone and color recreate the still, quiet atmosphere of an interior scene.

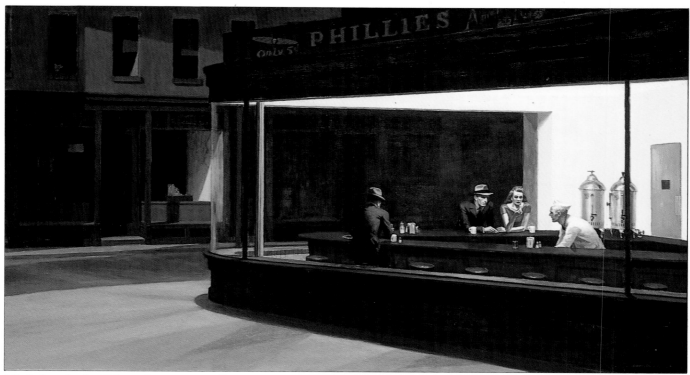

Nighthawks by Edward Hopper, oil on canvas

In Hopper's work, a figurative motif is reduced almost to an abstraction of light against dark, as this black and white version shows *above*.

Through his paintings of deserted streets and train stations, shabby buildings and melancholy figures, Edward Hopper expressed the loneliness and isolation of small-town and city life in twentieth-century America. The city scene in **Nighthawks** is filled with a sense of anxiety and alienation, yet at the same time there is a sad and touching beauty about these lonely figures in a café. The mood of the painting is conveyed through a highly organized compositional structure in which all trivial detail is eliminated and stark geometric shapes of light and dark emphasize the bleakness of the environment. A harsh fluorescent light shines ruthlessly on the people, making them seem more vulnerable, and the harsh, intense colors add a menacing note.

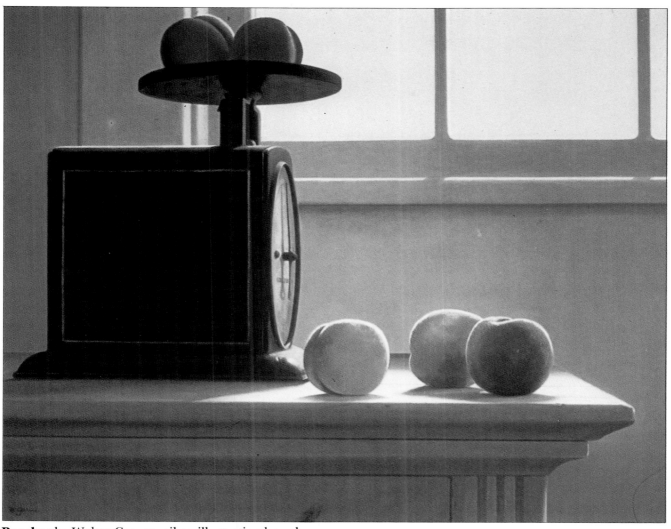

Peaches by Walter Garver, oil on illustration board

Walter Garver is an American painter who, like Edward Hopper, is interested in the mood-giving effects of both daylight and artificial light. In **Peaches,** we find the same still, timeless quality typical of Hopper's paintings. The precision with which the objects are placed, the stark contrasts in value and the smooth, matt finish of the paint surface all conspire to create a surreal atmosphere and a solitary mood. Strong backlighting reduces the forms of the peaches almost to silhouette, except for a luminous rim of light along their tops.

In this black and white version *above,* you can see the stark, geometric structure of the value pattern and how beautifully balanced it is. In Chapters 6 and 7, you'll discover how to organize tonal values to enrich the design quality and the mood of your paintings.

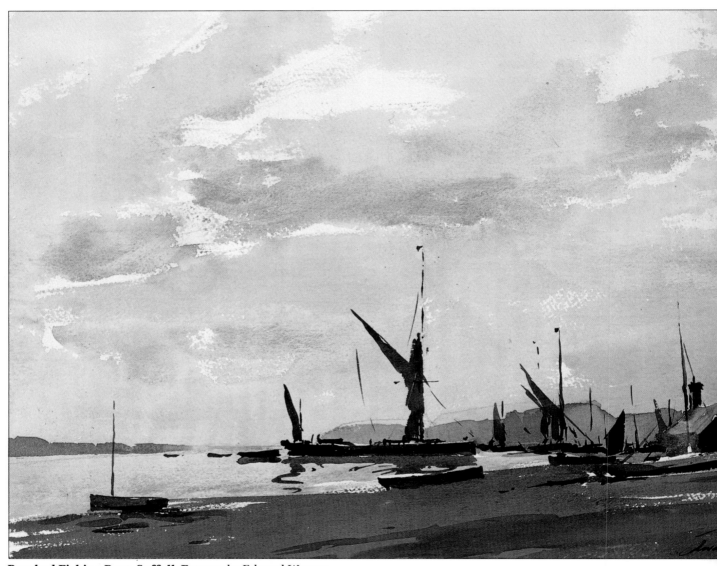

Beached Fishing Boat, Suffolk Estuary by Edward Wesson

UNDERSTANDING TONAL VALUES

Painting and drawing are an extension of the art of seeing; by viewing a familiar object in an unexpected way we often gain new insights not only into the physical world around us but also into ourselves and our own individuality. This intensity of experience inevitably comes through in our paintings and drawings, which take on a greater power and beauty.

Accordingly, the projects and demonstrations in this chapter are designed to develop your awareness of tonal values through close observation and intelligent enquiry. You'll learn how to spot those dynamic shapes of light and shade that lend poetry to even the most ordinary subject; how to make sense of a complex subject by making value sketches; and how a convincing illusion of reality can be achieved by working with a limited range of values.

If all this sounds like hard work – it is. But as any artist will tell you, painstaking observation is as vital to successful picture-making as the knowledge of practical techniques. Added to which, the discovery and understanding of what makes a thing tick is always a rewarding and exciting experience in itself.

WHAT ARE TONAL VALUES?

THEIR IMPORTANCE IN PAINTING

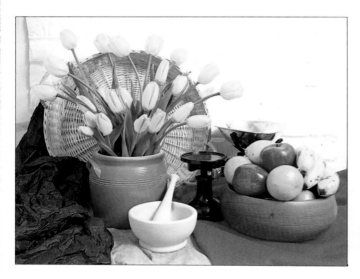

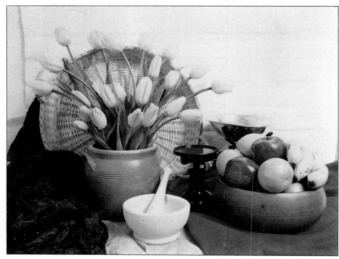

The word "value" simply refers to how light or dark an area is, whatever its color. Some colors reflect more light than others, which is why we perceive them as being paler in value. For example, navy blue and sky blue are both the same basic color, but navy blue is dark in value, while sky blue is light in value.

In addition, the value of a color is changed by the way the light falls on it, so that one color can show a variety of values. Imagine a man in a navy-blue sweater standing in front of a window so that he is at right-angles to you. His sweater is all made of the same color of wool, but you'll notice how its value appears darker at the back than at the front, where the light from the window is striking it.

The idea of tonal values is easy to understand if we look at it in terms of black and white. Every color (every pure, unmixed color, that is) has a tonal "value," ranging from white to black and with infinite shades of gray in between. You can test this by looking at a black and white photograph of a painting, or by adjusting the knob of your color television set until the picture goes black and white. In black and white, a yellow object looks almost white in value; red and green objects are similar in value, appearing as a middle gray; brown and purple appear dark gray, and so on.

Now we have defined what values are. But why are they so important in painting? What is all the fuss about? Quite simply, the value framework of a picture – the contrast of light and dark areas – can be compared to the skeleton of the human body, or the foundations of a building. Without this solid framework, the whole thing would collapse. In any painting, we have to be aware of the *weight* of each of the colors we use

and how they balance each other; otherwise the picture won't hang together well, nor will it convey a realistic sense of form (think of a black and white photograph that has been over-exposed so that everything appears the same light gray).

Some artists maintain that the value of a color is more important than the color itself. Even a great colorist like Paul Cézanne (1839-1906), who emphasized color changes to model form, was aware of the significance of the values of the colors he used. We shall see later on in this book how vital is the role played by the interaction of light and dark values – but the first step is to learn how to train your eye to *see* the values of colors and to judge them correctly.

This still life *above, left* contains a wide range of values, from very dark to very light. The intense colors in the fruit and flowers contrast with the muted colors of the other objects.

The same still life *above, right*, photographed in black and white, allows us to see the arrangement in terms of light and dark value patterns.

PUTTING IT ALL TOGETHER

Rendering an object or form realistically requires careful observation and an understanding of how tonal values are affected by light. When you're faced with a complex subject such as the human figure, it's easy to become confused by the profusion of lights, halftones and shadows, so that you lose sight of the main value shapes that describe, for example, the rounded form of the head.

The best way to avoid this sort of confusion is to sit down and make a series of pencil sketches that examine the value pattern of your subject – in other words, the main shapes of light and shade that most clearly describe what is going on. Forget for the minute that you're painting a head, or a flower, or a tree, and think purely in terms of patterns of light, medium and dark values. Try to adopt this analytical approach from the start, for once you understand the logic of how the light is falling on your subject, it will be much easier to express it in your painting.

Every subject has a "local" value that describes how light or dark its actual color is. For example, a red apple is darker than a yellow grapefruit, because red absorbs more light than yellow does. But local values are modified by the effects of light and shade, and it is these modifications that describe the form of an object. So in bright sunlight, the highlight on the red apple might be almost as light in value as the yellow grapefruit is, and similarly, the shaded part of the grapefruit may be almost as dark in value as the red apple.

Thus, the full value range of anything you look at is a combination of local value and the pattern of light and shade falling on the subject. Each has influence on the other – as demonstrated in the figure drawings below. In the first drawing, the artist has blocked in the local values of the model; the local value of the hair is dark, as is the value of the sweater she is wearing. Her face and hands are light, and her skirt is middle in value. The model is lit by a strong overhead light, however, and this creates a definite pattern of light and dark. Now the artist makes a separate drawing, to help him understand the pattern of light and shade falling on the figure. Local values are ignored for the moment.

In the final drawing, we see how the local values and the light and shadow pattern are combined. Remember that the local values will have an influence on the values created by light and shade; notice, for example, that although the same light is striking both the skin and the hair, the highlights on the skin are lighter than those on the hair, because the local value of the hair is darker. Similarly, the shadow side of the hair is darker than the shadow side of the face.

It is this interplay between local values and light and shadow that makes a drawing or painting visually exciting; the underlying local values lend a harmony and cohesiveness to the image, while the pattern of light and shade playing on the surface creates intriguing light/dark rhythms for the eye to explore and enjoy. Remember that a strong, direct light source will create interesting shadows – and therefore interesting value patterns. With flat, indirect light such as you would find on a hazy day or under fluorescent lights, there are few descriptive shadows and the image is made up of local values only.

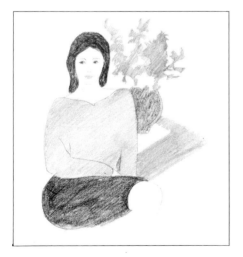

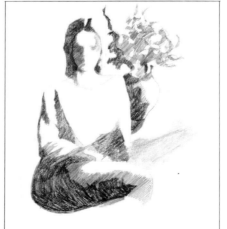

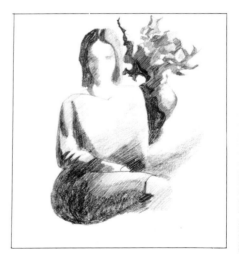

Local values... ... plus light and shade... ... combine to create form.

MAPPING VALUES

LEARN TO SIMPLIFY

Before you can render values successfully, you have to be able to perceive them accurately. This is not always as easy as it sounds, because other aspects – such as color and pattern – are apt to confuse the issue. But it is vital that you understand the way light falls on a subject, so that you can render it with force and clarity.

In this respect, a drawing method known as "mapping" is a great help in enabling you to make sense of a seemingly complex subject. Mapping involves making a simple outline drawing of your subject, and then breaking down the shape thus created into definite areas of light and shade. The idea is to take the many tonal variations you can see and reduce them down to just two – light and dark. In this way you get straight to the essential patterns created by light striking the subject – the shapes that not only convey three-dimensional form but also lend a particular mood or atmosphere to the subject.

Mapping works best when the subject is brightly lit, creating a strong pattern of light and shadow. Decisiveness is the key to this exercise – you have to group similar values into one overall value so that you end up with just a few clearly contrasting values. Keep the patterns large and simple, with a definite "boundary" line around each – think of it as building up a "jigsaw" of shapes. A helpful trick is to half close your eyes when looking at the subject; this has the effect of reducing the colors you can see, while simplifying the values.

Of course, it may seem a little crazy to use lines in a tonal drawing – and it is certainly something to be avoided when you're making a "proper" drawing or painting. But remember that mapping is not an exercise in drawing; it's an exercise in *seeing*, so don't worry about what the finished drawing looks like. Mapping forces you to look at your subject in an analytical way and evaluate one value in relation to another.

Mapping can be used in quick sketches *left* or as the basis for a full tonal study *below*.

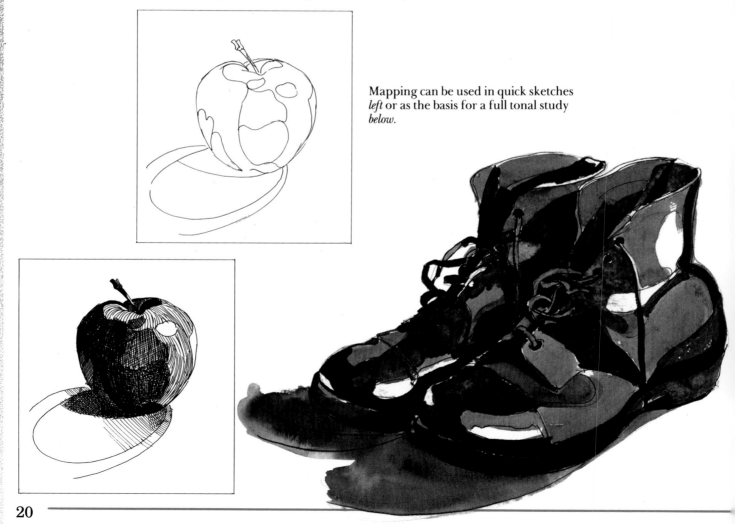

Project: Tonal collage

Mapping is an aid to observing and defining the patterns of light and shade on a subject by drawing lines around them. But in reality, objects don't have lines around them; they consist of a series of *masses* of light, medium and dark value. To help you think in terms of organic masses rather than rigid outlines to be neatly filled in, try this project.

Find a magazine photograph of a human face with strong light and dark contrasts. On a large sheet of paper, make a very light outline drawing of the face, without any shading. Now make a paper collage of the face. Cut out pieces of light, middle and dark valued newspaper and tear them into shapes that correspond with areas of light and shade on the face. Glue the shapes in place, overlapping each other, letting the white of the drawing paper serve as the highlights. Don't draw any lines – just tear the paper shapes as accurately as you can and glue them in place. You'll find it tricky at first, without pencil lines to guide you, but you'll soon get the idea of values and colors merging into each other with no hard outlines.

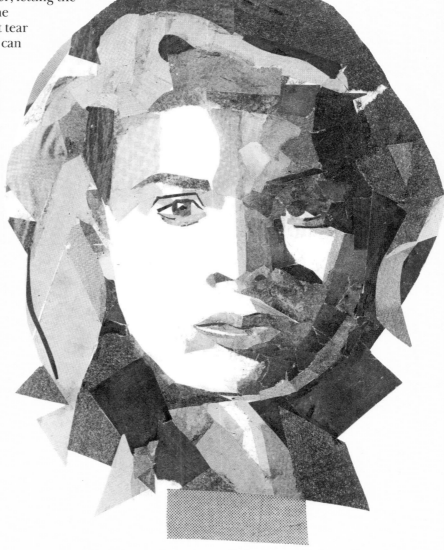

Making a torn paper collage will teach you a lot about judging values accurately – and can produce very striking results.

Self-critique

◆ Were you able to treat features as shapes rather than things?

◆ Did you use both cut and torn shapes to create a variety of hard and soft edges?

◆ Is your collage bold and simple, consisting of the larger masses of light and dark?

MAKING VALUE SKETCHES

ORGANIZE YOUR COMPOSITION

Having trained your eye to perceive values, you're now ready to move on to the next stage – using tonal values to create a balanced and unified composition. In nature the range of values from the darkest dark to the lightest light is extremely wide – far wider than we could ever hope to attain in a painting. As artists we are obliged to select from nature only those elements that seem to capture the essential spirit of the subject, and ignore the inconsequential details; in order to give a painting more force, we have to portray what we see in a crystallized form. The problem is that, when faced with a complex subject like a landscape, we "can't see the wood for the trees". So how, when confronted with a profusion of shapes, values and colors, lit by changing light, do we begin this process of selection?

The answer is simple: before you begin painting, make a few pencil sketches of the subject in which you concentrate only on the main shapes and value masses. These sketches are useful firstly because they provide a way of getting familiar with the subject so you feel more confident when starting to paint it, and secondly because you can use them to try out different arrangements of lights and darks until you arrive at the one that seems best. There's an old carpenter's maxim that says "measure twice and saw once." Making preliminary sketches will save you a lot of time and frustration at the painting stage, when adjusting the value composition would be much more difficult.

ASSESSING THE VALUES

During the eighteenth century, landscape painters often used a device called a Claude mirror to help them see more clearly the simple pattern of lights, darks and middle values in a landscape. This comprised a piece of darkened mirror glass which, when held up to the subject, reflected the image in a lower key. It also reduced the image in size, enabling the artist to see a large stretch of landscape as it would appear picture-size. The device was named after the French artist Claude Lorrain (1600-82), who is well known for his beautiful tonal landscapes painted in mellow colors.

Today, Claude mirrors are no longer made, but you can achieve a similar effect by looking at the subject through a piece of tinted glass or acetate. This won't, of course, reduce the image in size, but it will cut out most of the color and detail so you can see a more simplified arrangement of values. Looking at the subject through sunglasses also works well.

When making your value sketch, work quickly and reduce everything to just three values – light, medium and dark (save the white of the paper for the lightest value). Does the finished sketch have a good balance of values? If it doesn't, feel free to arrange and rearrange the proportion and distribution of the light and dark areas, until something "clicks" and you feel happy with the way they hold together. It helps if you can temporarily disregard aspects like color and identifiable subject matter and look at the sketch as a flat, two-dimensional pattern of light and dark shapes. If this simple light/dark pattern doesn't hold together as a harmonious abstract design, then the painting will most likely fail. What you should strive for is a lively interplay of lights and darks that create a strong movement across the paper. The overall pattern should be simple and cohesive, consisting of a few large, interlocking shapes rather than a lot of small, fragmented ones.

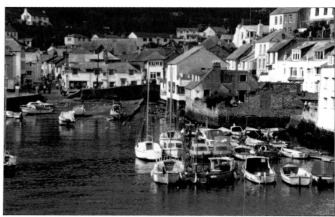

A harbor scene like this one *above* makes an attractive painting subject. The only problem here is that the overall value pattern is too busy and scattered.

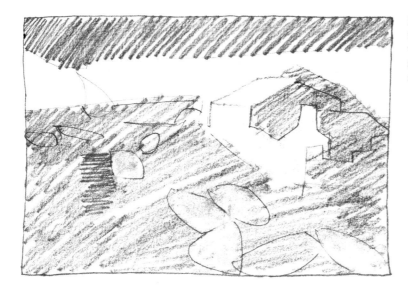

By half-closing his eyes, the artist reduces the scene to just three or four values. In this first sketch, *left,* he ties similar values together to make larger, stronger shapes.

Now he strengthens the areas of darkest value *right.*

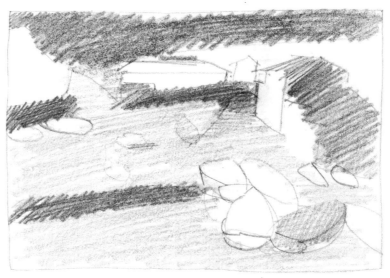

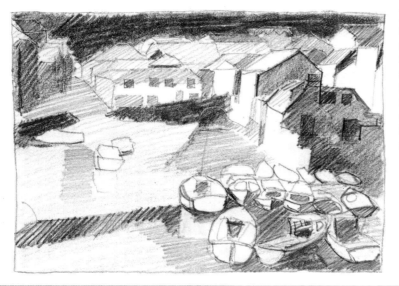

Having established the main value masses, he can fine-tune the sketch by adding the middle values and reinforcing the linear design *left.* The attractive layout of the harbor scene remains intact, but the composition is now stronger and more unified. The sketch will serve as the basis for a finished painting, made either on-the-spot or back at the studio.

START WITH FIVE VALUES

MAKE LESS SAY MORE

When a painting contains too many different colors, it is unsatisfying to look at because the colors end up by canceling each other out. Exactly the same thing applies with values – too many will cause a painting to look confused and disjointed. Of course we can discern literally dozens of different values in nature – and there is nothing in nature that looks confused or disjointed – but for the purposes of picture-making we need to reduce the number of values we see to just a few, in order to make a clear, uncluttered statement. Indeed, one of the most useful lessons in painting is *how to make less say more*. It's a bit like giving a speech – if you include too many irrelevant facts, the listener will very soon become bored, whereas a few considered phrases, well delivered, will make a lasting impression.

Most painters tend to work with around nine to twelve values, but it is possible to create a perfectly good picture with just three to five. In fact, if the whole idea of tonal values leaves you feeling puzzled, a good exercise is to make a few paintings or drawings using only five values: white, a light value, a middle value, a dark value, and black. By doing this, you will train your eye to judge the value of any color correctly, and you will learn to see things in terms of broad masses instead of getting bogged down in small details.

A value scale like the one below is invaluable in determining the values of the colored objects you are painting. It gives you something positive to gauge the values of your subject by; you simply give each area of color a tone value from one to five on the scale, depending on how light or dark it is.

Start by drawing a bar 5in long and 1in wide on a sheet of white paper. Divide the bar into 1in squares. Leaving the first square white, take an HB pencil and lightly fill in the other four squares with hatched lines. Exerting the same degree of pressure on the pencil, go over the hatched lines again, this time starting with the third square. Now go over squares four and five again, and finally square five only. So long as you exert the same degree of pressure with the pencil each time, this should give you an even gradation in value from white to black.

It's a little more difficult to create a value scale in paint so that you get an even gradation. If I'm using watercolor I start by mixing up a full-strength solution of ivory black in a jar and then dividing it between four saucers. I keep one saucer "neat," to act as the darkest value. Then, to get my light, middle and dark grays, I add a teaspoon of water to the second saucer, two teaspoons to the third, and three teaspoons to the fourth. For the fifth value, of course, I simply use the white of the paper.

In oils and acrylics, the best method is to squeeze out measured lengths of black and white paint from the tube and mix them very carefully. Even so, achieving an even gradation of tones is quite tricky, and a lot depends upon the quality of the paints.

Pencil

Watercolor

Oil

Gouache

PROJECT: Still life in five values

One of the most fascinating aspects of still life painting is recording the complex interplay of shape and form, value and color, light and shade – qualities that make each still life unique. The aim of this project is to record those shapes and values as simply and expressively as possible – in other words, to get to the real essentials of the subject.

Set up a simple still life group similar to the one illustrated. It doesn't matter what you choose to paint, so long as the group includes a range of colors from very pale to very dark. Arrange the objects on a table against a wall, and light them from one side so that you get interesting cast shadows.

Use any medium you like, but stick to just five values. In order to keep the values consistent throughout, it's best to premix them beforehand.

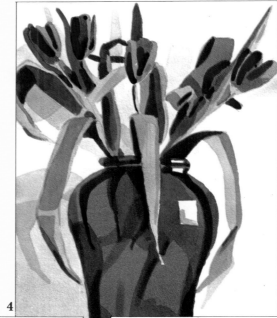

4

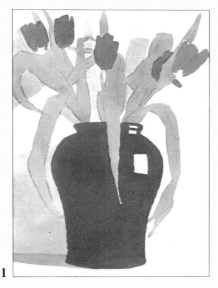

1

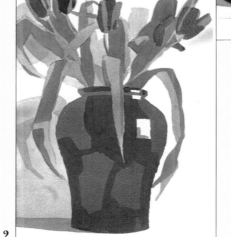

2

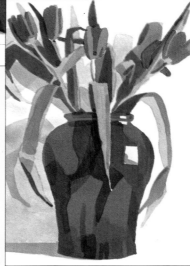

3

1 Highlights and light values
2 Pale mid-values
3 Dark mid-values
4 Darkest values complete the picture

Self-critique

◆ Did you half-close your eyes to see the value pattern more clearly?

◆ Did you lightly map with pencil the main areas of light and dark?

◆ Did you mix your washes accurately – not too dark and not too light?

◆ Did you keep your shapes simple and your brushwork direct?

WORK UP TO NINE VALUES

INCREASE YOUR RANGE

Having gained confidence in working with five values, a further four can be added to your repertoire. These new additions are really half-steps between the original five values; as you can see from the value scale below, they create an even smoother gradation from black through to white. Nine values will give you greater flexibility and allow you to tackle more complex subjects; they are enough to give your paintings greater subtlety and refinement, while still remaining easy to control.

The still life painting opposite is painted with only nine values of gray, yet it conveys a solid and convincing sense of form. It's interesting to notice how the local value of each object affects the value of both its light and shadow planes.

Avoid over-emphasizing the lights in a dark area, and the darks in a light area, otherwise you will destroy the illusion of light. Always key your light values to the upper end of the value scale, going no darker than a middle value, and your shadow values to the lower end of the scale, going no lighter than a middle value.

Above **Ladder fern** by Charles Inge, watercolor. This simple plant study has a freshness and delicacy appropriate to both the subject and the medium. The artist has avoided any tendency to overwork the subject by sticking to a restricted value range and a limited palette of colors.

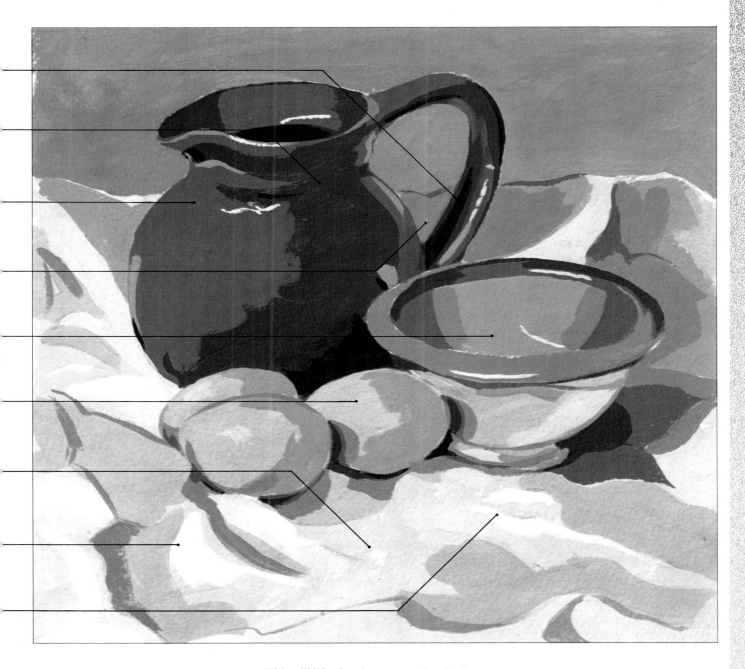

This still life *above* is an example of using just nine values to model objects that have varying local values. Try painting similar studies in monochrome. You'll soon discover that achieving a solid and convincing sense of form is largely a matter of treating things simply.

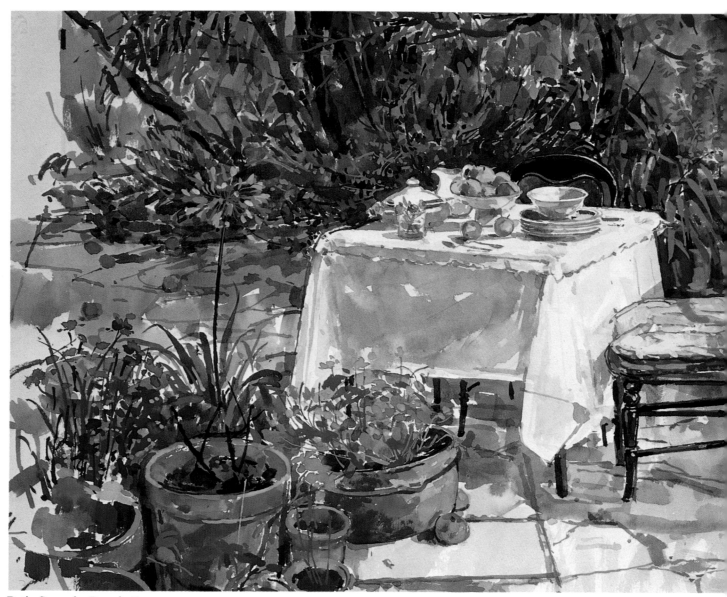

Patio Scene by Pamela Kay

Pamela Kay

·3·

VALUE AND COLOR

It is easy to understand tonal values in terms of black, gray and white. However, it is a colorful world in which we live, and the hues and intensities of some colors are difficult to define in terms of values. You may recognize an orange as being intense and warm in color, but does it have a light, middle or dark value? The very intensity of the color can trick your eyes into seeing the value of the orange as lighter or darker than it really is. Add to this the fact that colors and values are modified both by their surroundings and by the prevailing light, and it's little wonder that confusion sets in!

Nevertheless, it's important to be able to see colors in terms of value so that we can achieve unity in a picture by balancing the "weight" of one color against that of another. A picture may contain a wide range of colors, but still look flat and unconvincing if it lacks contrasting values; equally, too many different colors in a painting can create too many different values, and this leads to a confused and disjointed image.

The aim of this chapter is to help you understand more about the colors you choose to use in a painting and how they relate to one another.

THE LANGUAGE OF COLOR

UNDERSTANDING THE TERMS

When considering the values and colors in a painting it is useful to know something about their characteristics and the way they react together. It is not my intention in this book to "blind you with the science of color," and besides, there are many excellent books that cover the subject in great depth. However, since the terminology used to describe the properties of color can be confusing to the uninitiated, let me begin this chapter by defining some of the basic terms and explaining how color can be used to achieve greater expression in your painting.

Every color has four basic properties: hue, value, intensity and temperature.

Hue is simply the name given to a color in its purest and simplest form, such as red, green, blue etc., regardless of variations caused by the way the light falls.

Value refers to the lightness or darkness of a color. For example, light and dark red are of the same *hue* but different in value. Value contrasts have great visual impact, but they need to be controlled in order to preserve the unity of the composition.

Intensity refers to the relative strength or weakness of a color. Colors used straight from the tube are at their most intense; mixing them with other hues reduces their brilliance. For example, cadmium orange is an intense hue, but when mixed with any other color it loses some of that intensity and becomes more neutralized. Pure, intense colors appear even more intense when placed within areas of neutral hue – they are emphasized by contrast. Too many intense colors in a painting can have a tiring effect on the eye; in a painting of brightly colored flowers, for example, it is advisable to include some restful neutral passages to provide welcome breathing spaces.

Temperature Colors are referred to as being "warm" or "cool." Reds, oranges and yellows are generally classed as warm, whereas blues, greens and violets are classed as cool. However, within these divisions there are varying degrees of warmth and coolness: ultramarine, a blue that contains some red, is warmer than Prussian blue, which veers more toward green. Cadmium red is warmer than alizarin crimson, which has a hint of blue in it. Because warm colors appear to come forward and cool colors to recede, the use of warm hues in the foreground and cool ones in the background creates the effect of depth and atmosphere in landscapes.

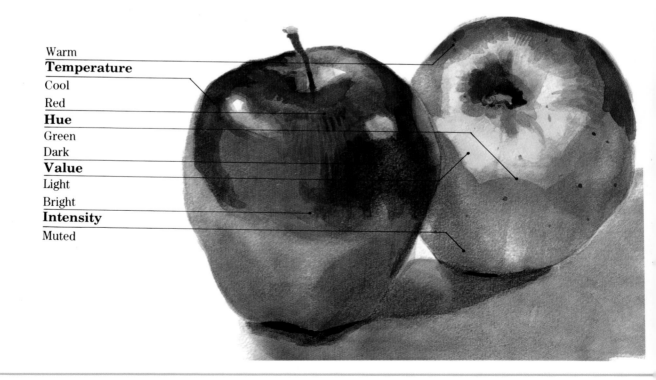

Warm
Temperature
Cool
Red
Hue
Green
Dark
Value
Light
Bright
Intensity
Muted

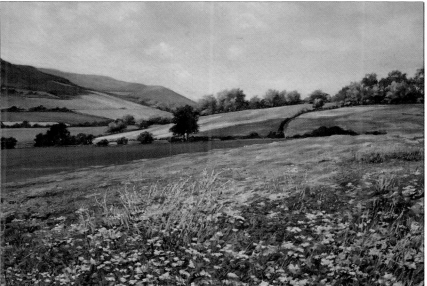

Closed Mondays by Joan Heston, oil on canvas, 31in×40in *above*. Yellows, blues, pinks and mauves are subtly woven throughout the composition, activating the entire surface of the painting. The colors are similar in value and intensity, creating a gentle harmony that is appropriate to the subject.

Summer Fields by Roy Herrick, oil on canvas *left*. The warm, intense reds in the foreground appear to advance, whereas the cool, grayed tones in the distance appear to recede, thus accentuating the impression of depth and atmosphere in this landscape.

Project: Color and value charts

It's important to be able to judge the tone values of your pigments when using them in color mixes. To help you judge value relationships accurately, try making color and value charts like those shown.

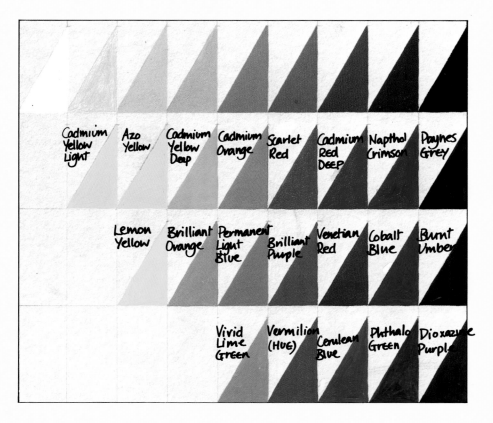

Within the chart the handwritten labels read:

Cadmium Yellow Light • Azo Yellow • Cadmium Yellow Deep • Cadmium Orange • Scarlet Red • Cadmium Red Deep • Napthol Crimson • Paynes Grey

Lemon Yellow • Brilliant Orange • Permanent Light Blue • Brilliant Purple • Venetian Red • Cobalt Blue • Burnt Umber

Vivid Lime Green • Vermilion (HUE) • Cerulean Blue • Phthalo Green • Dioxazine Purple

Chart A Draw a grid with nine vertical columns, each about 1in wide. Divide these horizontally into four sections to create 36 squares or rectangles (you can make more if you wish). Along the top section, make a nine-tone bar in your chosen medium. Start with white on the left, going through shades of gray to black on the right in an even gradation of values. Select ten or more colors from your palette, including intense reds, yellows and blues. Using pure, unmixed color, fill in the squares on the chart, trying to match each color to its relevant position on the black and white scale. Burnt umber, for instance, is very dark, so it is placed opposite black on the scale.

To test the accuracy of your placings, look at the chart in a dim light, or take a black and white photograph of it. If you have been successful, the chart should appear as four identical, evenly gradated bands of grays.

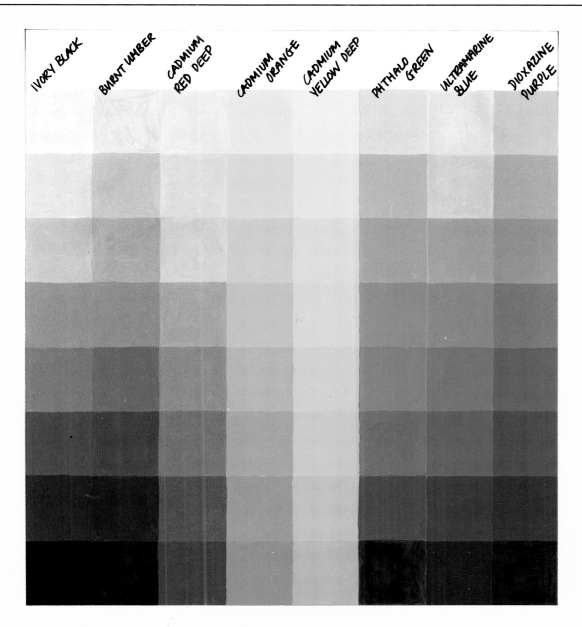

IVORY BLACK BURNT UMBER CADMIUM RED DEEP CADMIUM ORANGE CADMIUM YELLOW DEEP PHTHALO GREEN ULTRAMARINE BLUE DIOXAZINE PURPLE

Chart B Try a similar exercise, this time aiming to create an even gradation from light to dark within one color. Try it with several colors that are totally different, as in the chart above. This exercise is more difficult than the previous one. You can add white, or more diluent, to lighten the value of a color, but adding black to darken the value can alter the character of the color dramatically. Yellow, for instance, changes to green or brown when black is added.

Self-critique

◆ Do all your colored bands follow the same gradation from light to dark as the black and white scale? It's difficult to judge the values of intense colors such as scarlet red. They will "jump out" at you if you've positioned them inaccurately. Keep practicing!

HOW VALUES AFFECT EACH OTHER

ALL THINGS ARE RELATIVE

The colors and values in your painting should never be regarded in isolation, but in terms of how they relate to those around them. All colors and values are influenced by neighboring ones, therefore each touch of color you add to a painting alters the relationship of colors already there. For instance, a bright color appears richer when placed next to a neutral or muted color, which reinforces it by contrast. Similarly, a dark value appears even darker when juxtaposed with a light one. Such visual dynamics add greater interest and expressiveness to a painting.

Beginners often tend to work on one small area of the picture until it is "finished," and then move on to the next area. Not only is this a laborious way of working, it also leads to a confused and "jumpy" painting because there is no harmonizing influence to hold everything together.

Try to work on all areas of the picture at once. Work from landscape to sky and back again, or from figure to ground and back again. Keep your eyes moving around the picture, constantly assessing and comparing one color against another. Aim to balance warm colors with cool, intense colors with muted ones, and light values with dark. In this way, your painting will grow and develop in an organic way, emerging finally as a complete unit, a homogeneous mass of color and value. Painting is a continuous process of balancing, judging, altering and refining – which is what makes it so absorbing.

The examples that follow demonstrate some of the points to watch out for when assessing the relative values and colors in your paintings.

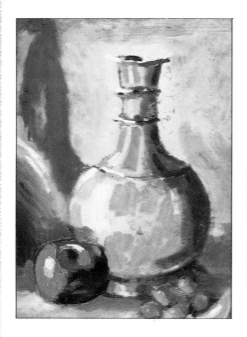

Depicting the effect of light on reflective surfaces can be confusing. In this still life *far left,* the artist has tried to give the impression of a shiny metal vase by piling on a lot of thick white paint for the highlights. The result is weak, like an over-developed negative, because the values in the rest of the image are also light; there is no tonal variation to interest the eye.

The old axiom that light is produced by sacrifice is demonstrated in this version *left* . Notice how the highlights on the vase and the apple appear to glow when surrounded by a large mass of dark values. The values available to us in paint are no match for the range of values found in nature, so a compromise must be made; to make an area of light value suggest brilliance, place it in opposition to strong, contrasting darks. Look at any portrait by Rembrandt and you will see this principle in action.

When modeling form through contrasts of light and shade, remember that strong value contrasts and strong color contrasts do not always work together. In this watercolor sketch *above*, the artist has used both and the result is garish and overdone.

This study of a pear *above* looks good enough to eat! Here the artist has used minimal color contrasts, relying on value contrasts to express the rounded form of the fruit. Notice the movement around the form from warm light to cool shadow.

Color pigments don't always behave as we expect them to when used in mixtures, and this can result in weak or muddy colors. If you add black to yellow to darken it, for instance, it turns a dirty shade of green or brown. Adding white to green to imitate the light, bright greens of nature only makes it cooler and less intense. So how do you adjust the values of your colors while retaining their strength and intensity? Often it's a question of adding, not black or white, but another hue closely related to the one you wish to alter. These two color charts give some examples of how to lighten and darken a hue successfully.

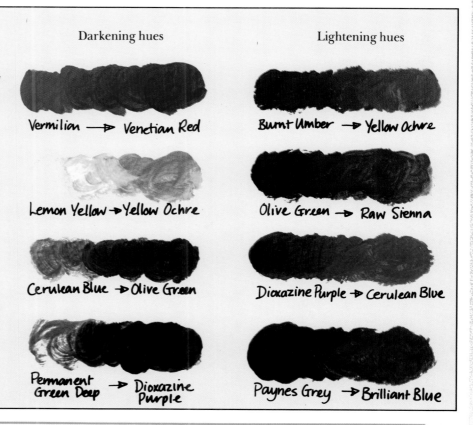

Darkening hues

Lightening hues

Vermilion ➡ Venetian Red

Burnt Umber ➡ Yellow Ochre

Lemon Yellow ➡ Yellow Ochre

Olive Green ➡ Raw Sienna

Cerulean Blue ➡ Olive Green

Dioxazine Purple ➡ Cerulean Blue

Permanent Green Deep ➡ Dioxazine Purple

Paynes Grey ➡ Brilliant Blue

MARKET ON A BLUSTERY DAY

Go down to your neighborhood street market and you'll find enough visual material to keep you painting for weeks. All those wonderful colors and shapes, the hustle and bustle, the atmosphere of fun and excitement . . . but how do you capture it all in paint without getting hopelessly lost in the details? In this demonstration, artist Tom Coates explains his "grapeshot approach" to painting a complex subject.

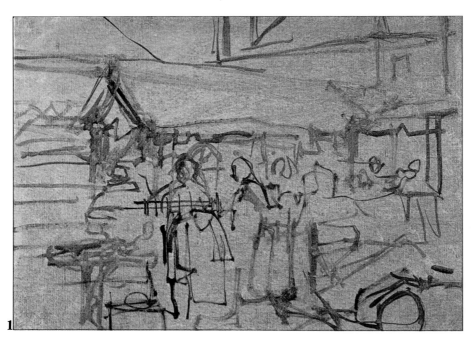

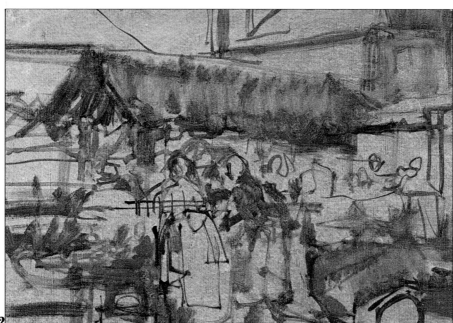

1 By "grapeshot approach" I mean working on all areas of the canvas at once, so that the picture emerges as one entity and the colors and values relate to each other comfortably. If you work in piecemeal fashion, not only will you get bored very quickly, but your painting will finish up looking disjointed.

I always begin by staining my canvas with a neutral gray, made by mixing permanent green, burnt umber and a touch of titanium white. This kills the stark white of the canvas and gives me a sympathetic middle value from which I can work outward to my darks and lights. I mix the paint fairly thinly, using a mixture of 90 per cent turpentine to 10 per cent oil as a diluent. Then I rub the paint into the grain of the canvas with a rag or with the heel of my hand, and allow it to dry for 48 hours before painting on top of it.

The next stage is the under-drawing, for which I use a round no. 6 softhair brush and a fluid mixture of burnt umber and cobalt blue. I work rapidly, never lifting the brush from the canvas but letting it skim lightly from one area to another. Don't get bogged down in details at this stage – relax, enjoy the subject, and if the figures move, move with them.

2 Now I start blocking in the main areas of cool color, using a mixture of cobalt blue and titanium white. I use the paint quite dry, flicking it over the surface of the canvas with the side of the brush.

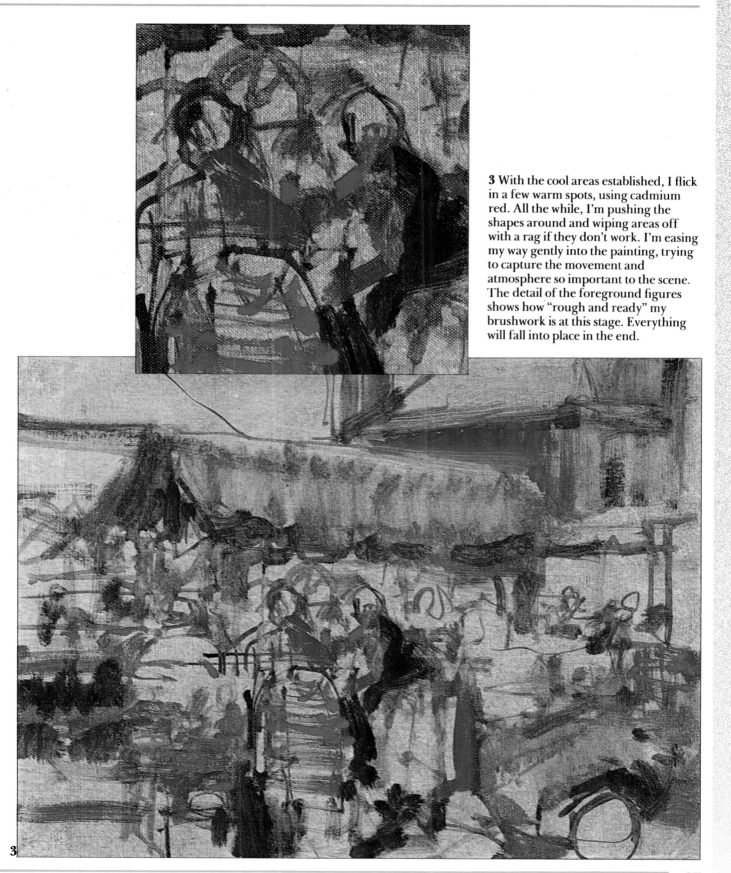

3 With the cool areas established, I flick in a few warm spots, using cadmium red. All the while, I'm pushing the shapes around and wiping areas off with a rag if they don't work. I'm easing my way gently into the painting, trying to capture the movement and atmosphere so important to the scene. The detail of the foreground figures shows how "rough and ready" my brushwork is at this stage. Everything will fall into place in the end.

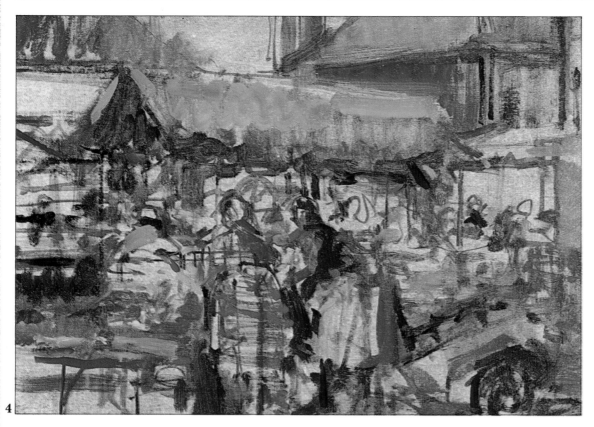

4

4 I continue flicking in spots of color all over the canvas, still getting the feel of things. My brushwork is very loose and rapid – I need to keep things flexible because there's a lot of activity going on. The three figures in the foreground are stallholders. Although they are moving all the time, I notice that they repeat certain gestures as they go about their work, such as weighing out fruit, so I try to retain those gestures.

5 Now I start to push the paint around and meld together all those loose strokes of color while they're still wet. Notice how each area of the canvas is at the same stage of development. No one area is allowed to take precedence over another.

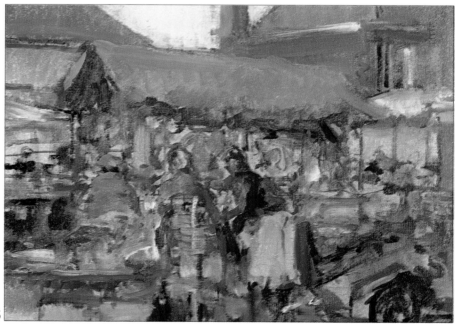

5

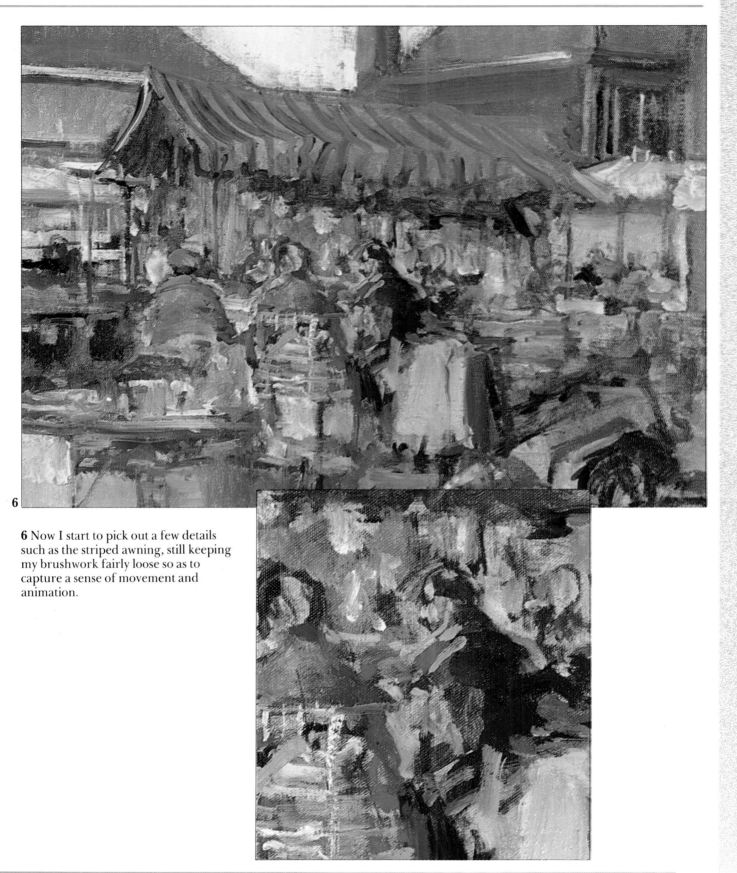

6 Now I start to pick out a few details such as the striped awning, still keeping my brushwork fairly loose so as to capture a sense of movement and animation.

7 In the final stage *right* I add a few highlights to give the picture more snap. The process of making a painting is rather like adjusting the lens of a camera and watching the image in the viewfinder slowly come into focus. This particular painting was completed in less than two hours. I worked rapidly on the spot because my aim was not to give a photographic representation of the scene but to capture something of the atmosphere of a bustling market.

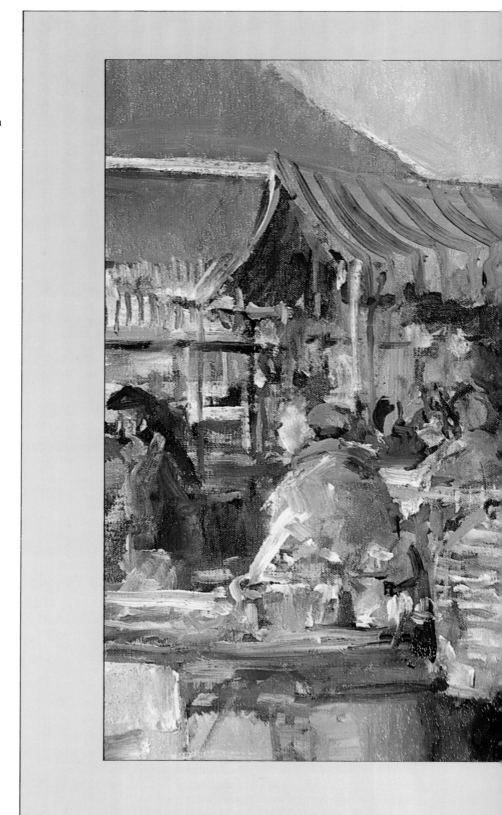

7

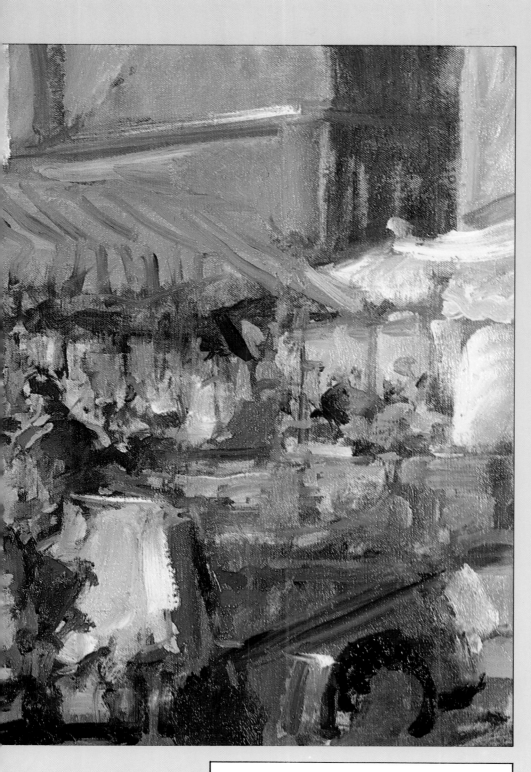

MARKET ON A BLUSTERY DAY

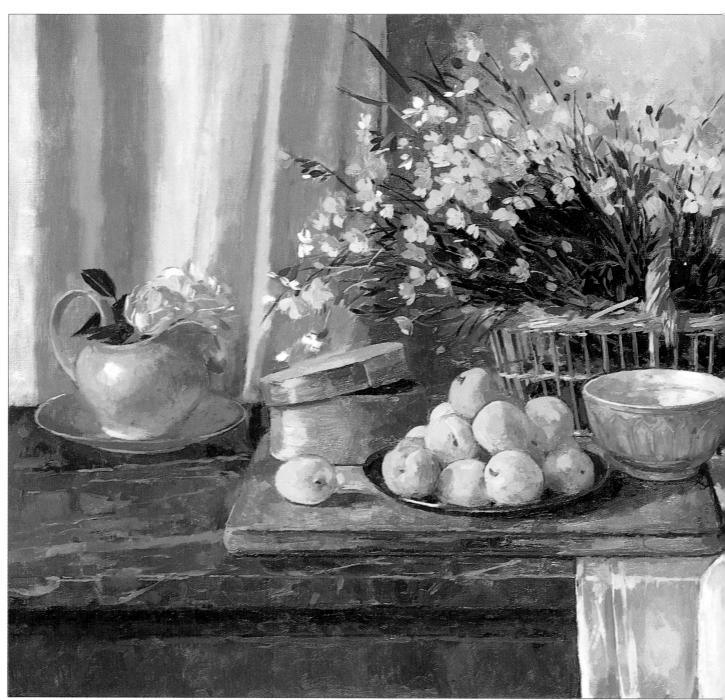

Still Life with Apricots and Buttercups by Pamela Kay

MODELING FORM

Most realistic painting is concerned with representing solid, three-dimensional objects on a flat, two-dimensional surface. The artist's task is to create what is really an optical illusion – the "impression" that these objects have weight and volume as well as outline.

What contributes most to this illusion is the play of light and shade on the subject – as represented by light, middle and dark values which help us to "read" how the object is formed.

When it comes to learning how to model form, there are no shortcuts, no clever tricks, no mysterious secrets. All you need is the ability to observe closely the way in which light strikes forms and the skill to evaluate lights, middle values and shadows accurately.

This chapter guides you through the logical process of describing three-dimensional objects realistically. You'll learn how to see objects in terms of simple shapes, how to describe the effect of light on forms, and finally how to use hard and soft edges to convey the character and solidity of objects.

HOW LIGHT MODELS FORM

THE LOGIC OF LIGHT

The process of rendering the solid, three-dimensional appearance of objects may seem complex at first, but this process is made easier when we approach it in a methodical way. Basically there are two things to remember:

1 Even the most complex shapes in nature are based on four simple geometric forms: the cube, the sphere, the cone and the cylinder. An automobile is basically a cube; a tree consists of a sphere on top of a cylinder; mountains and sand dunes are cone-shaped; arms, legs and torsos are all variations on the cylinder.

2 Light always strikes these forms in a logical and consistent way, creating a logical and consistent pattern of lights, darks and middle values.

These observations may seem over-simplistic but, like training wheels on a bicycle, they will help develop your confidence until such time as you feel able to discard them and get along on your own. By seeing things initially in terms of simple shapes and values, we can understand them – and understanding a thing is at least half the battle.

The illustrations below demonstrate how patterns of light and shade are formed on a cube, a sphere, a cone and a cylinder. You'll see that each shape has a definite light side and shadow side. In addition, there is a half tone between light and shadow. Notice the sharp division between light and shadow where one plane meets another on the cube; compare this with the gradual transition from light to shadow on the rounded forms.

If you look carefully, you'll also see a small sliver of light near the outer edge of the shadow side of the object – this is reflected light which bounces up from the light-colored surface and into the shadow area. The value of the reflected light needs to be judged carefully – it is darker than the light side, but lighter than the shadow side.

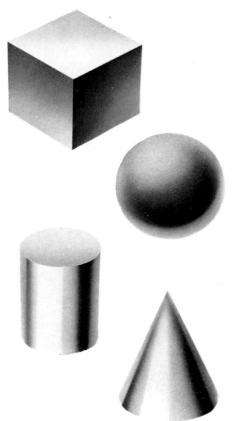

These diagrams *left* show the consistent pattern of light and shade that falls on a cube, a sphere, a cone and a cylinder. The angle of light reflected off the curved forms changes constantly; consequently the shadow tones are more gradated than those on the sharply defined planes of the cube.

Cast shadows are important in anchoring an object to the surface it rests upon. They are darkest where they meet the object, becoming lighter at the edges, and they vary in size and shape according to the angle and distance of the light source.

Shown *right* are four permutations of varying light sources: **1** low light source from left, **2** high light source from behind left, **3** low light source from behind, **4** low light source from right.

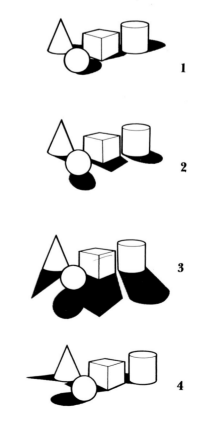

Project: Light on basic forms

Collect together four objects that resemble in shape a
cube, a sphere, a cone and a cylinder. Simple objects
from around the home will do, such as a cardboard
carton, a grapefruit, a lampshade and a bottle. Place
each object on a table and direct a strong light onto it
from one side so as to create a definite pattern of light
and shadow on the form.

 Using any medium you choose, try to render each
object using only three or four values. Use the light
and dark patterns to help define the forms.

 As an extension of the project, you could render the
same objects again, but this time with the light source
coming from another angle. Or place all four objects
together in an interesting arrangement and record
how shadows and reflected light are cast from one to
another.

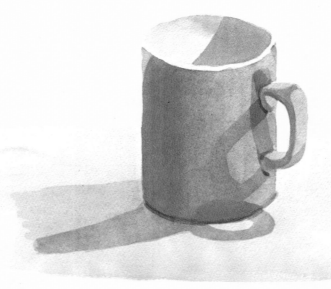

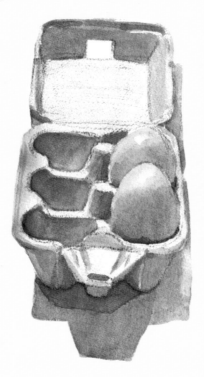

These simple objects were rendered in
watercolor, using overlaid washes to
build up depth of tone in the shadow
areas. The mug is basically a cylinder,
the egg an elongated sphere, the egg
box a cube, and the molded shapes
within the egg box are conical in shape.

Self-critique

◆ Did you include the highlights,
 shadows, cast shadows and
 reflected light on each form?

◆ Did you build up the values
 patiently, working from lightest
 to darkest?

◆ Did you use both hard and soft
 edges to accentuate the contours
 of the forms?

◆ Did you try moving the light
 source to find the light/dark
 pattern that best expressed the
 form?

USING LIGHT TO ADVANTAGE

"PAINTING" WITH LIGHT AND SHADE

The way light falls on an object tells us whether it is flat or curved, square or spherical, and so on. But certain kinds of light reveal form more clearly than others because they create a stronger pattern of light and shade – which of course we interpret in our paintings through the use of contrasting values.

As the sun moves across the sky it casts a variety of light and shadow patterns that can completely transform the appearance of the landscape from one part of the day to another. Look at a landscape at midday, for instance, when the shadows are shortest, and you'll notice how objects appear curiously flat and formless. The same scene viewed in the early morning or late afternoon, when shadows are more prominent, looks much more strongly modeled.

Sometimes you may want to deliberately create a flat, two-dimensional effect in your painting – for example, when the subject contains interesting patterns or colors that you want to emphasize. However, if you want to express form realistically the interaction of light areas, middle values and shadows is essential.

Whether you're working outdoors or in the studio, give careful thought to both the amount and the direction of the light and how these affect the appearance of the subject. Indoors, you can control the strength and the position of the lighting to achieve the effect you want. Generally it is best to stick to a single, fairly strong light source that casts a strong pattern of light and shade, since multiple or diffused lighting creates conflicting values that can destroy the sense of form. With outdoor work, it's a question of returning to the scene at different times during the day, or during different weather conditions, until you find the lighting effect that brings out the forms most clearly.

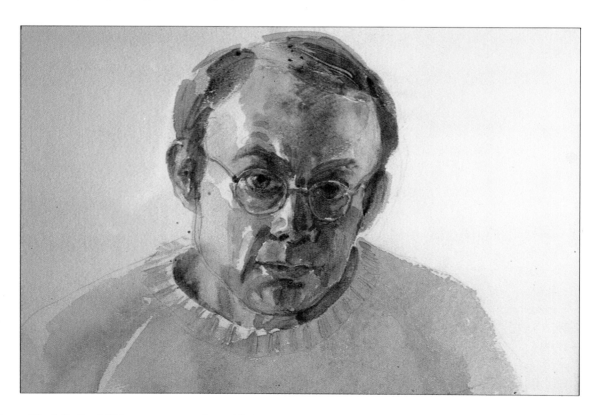

The Artist at Work by David Hutter, watercolor *above*. With the right kind of lighting, the task of modeling even complex forms becomes much easier. In this self-portrait, a strong light comes from the sitter's right, and some reflected light strikes his left side. This creates strong values in the center of the face, which is the foremost plane. The artist accentuates the features here, using overlaid washes and glazes. The sides of the head, being receding planes, are relatively less defined. This transition from strong modeling to soft creates the illusion of the rounded form of the head.

These two watercolor sketches demonstrate the important role played by light and shade in accentuating the form of objects. The artist has chosen his viewpoint well *right*. By looking up at the church from the bottom of the hill, he emphasizes the scale and grandeur of the old building. Instead of a straightforward frontal view, he chooses a three-quarter view that allows us to see both the front and side planes of the church, thus giving a reasonable impression of form and volume. However, the scene was painted under the diffuse light of an overcast day. The absence of shadows renders the scene rather flat and lifeless, and the intricate features of the church are not brought out at all.

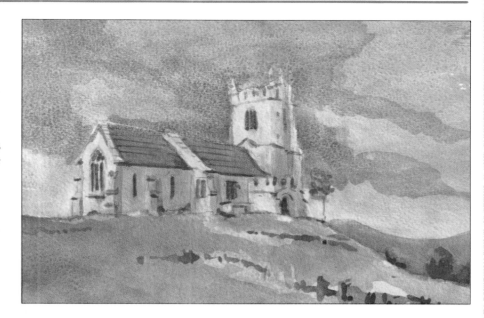

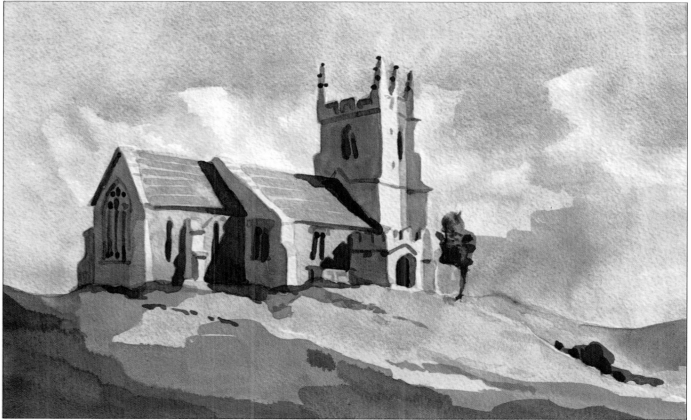

The same scene *above,* this time painted on a bright, breezy day. The sun, cutting through a gap in the clouds, illuminates the church at a three-quarter angle. The planes facing away from the sun are in deep shadow, and strong cast shadows add further interest. This strong light/dark value pattern not only brings out the form of the building, it also activates the picture surface and makes it more interesting to look at.

FOUR KINDS OF LIGHT

The landscape sketches shown below, illustrating the same scene under different lighting conditions, show what a vast difference the angle of the light can make in creating the impression of form.

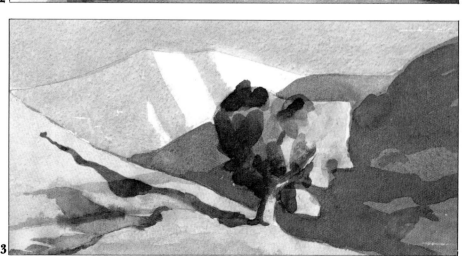

1 Front light The light falls on the subject from the front, casting deep shadows behind it and out of sight. Very little texture or modeling is apparent. The near-absence of shadow means that there is little tonal variation, resulting in a rather flat, two-dimensional image. This type of light is best if you want to accentuate color rather than form.

2 Top light The strong overhead lighting found at midday casts deep shadows directly beneath the subject, with the edge of the shadow running across the center of each object. This gives a reasonable impression of volume, but it distorts detail and is therefore not ideal.

3 Side light Light falls on the subject from one side, throwing the other side into shadow and creating a strong cast shadow. This gives quite a good sense of volume, but there may be a lack of detail in the shadows. The edge of the shadow runs down the center of each object. Side lighting is used to create dramatic effects rather than to emphasize form.

4 Three-quarter light Light falls on the subject from a 45° angle, creating a strong impression of form and volume as well as picking out details of surface texture. This is the type of lighting most frequently used, because it provides a good balance between side light and front light.

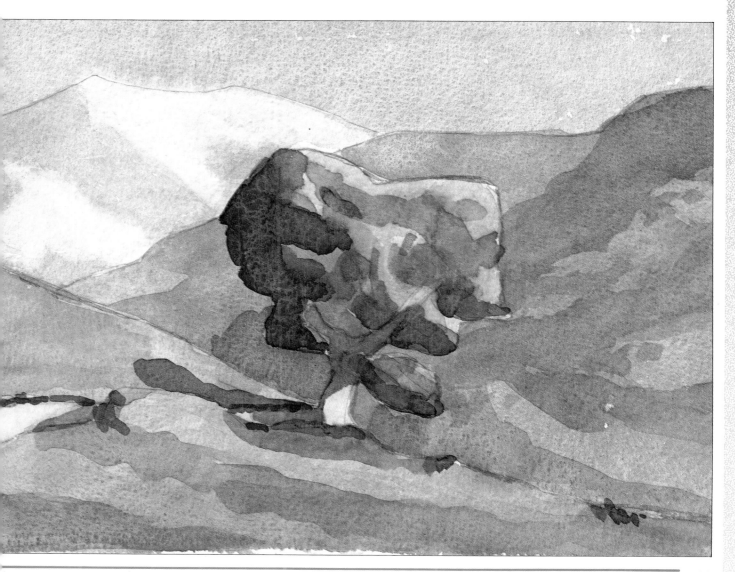

HARD AND SOFT EDGES

VARY YOUR EDGES TO EXPRESS FORM

The word "edge" implies something sharp and well defined, such as the edge of a knife or a ruler. In reality, however, some edges are sharp and precise while others are soft and vague. Learning how to handle hard and soft edges (sometimes called "lost and found edges") is important, because it is an effective way of conveying the character and solidity of an object.

Beginners are often over-anxious to follow the exact contour of every edge in an attempt to create a photographic likeness. This not only gives the painting a hard, brittle look, it also destroys the sense of three-dimensional form because it ignores the fact that where a form is indistinct or gently curving, where there is low contrast of value between two areas, or where an object is in the far distance, an edge will appear softer and less distinct. You can test for yourself the difference between hard and soft edges by making drawings of crumpled white paper and crumpled white fabric; the folds in the fabric will have softer edges than the folds in the paper, because the fabric is softer. However, it is also worth noting that a fold in any material will change along its length from being sharp at the source of the fold to being round where the fold peters out or moves into the light; therefore its edge will vary from crisp to soft.

When modeling a complex subject like a portrait, observe carefully how the light strikes the forms and vary your edges accordingly. The human face, for example, is a complex mass of hard and soft edges. Sharp creases and bony areas such as the bridge of the nose appear "harder" than the soft curves of the cheek and forehead. Similarly, the light-struck contours of the face appear well-defined, while the contours on the shadow side are less defined. Orchestrating these contrasts not only achieves a convincing representation of three-dimensionality, but also imbues the painting with richness and beauty.

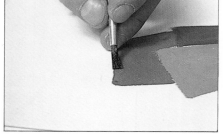

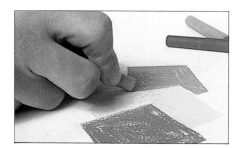

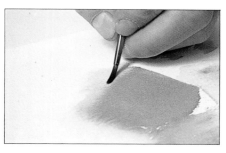

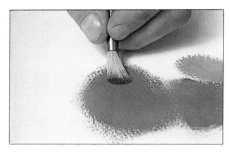

Watercolor To create a hard edge in watercolor, work on dry paper *above*. Another way is to drop a little clear water onto the wet color; this pushes some of the pigment outward, and it dries with a hard edge. For a soft edge, dampen the color with clear water and a soft brush *bottom*

Oil To create a crisp edge in oils, use a flat or filbert brush *above*. For a soft edge, blend two areas of tone or color wet-in-wet with a soft brush *bottom*.

Pastel To create a hard edge in pastel, use the side or point of a hard crayon and apply plenty of pressure *above*. Soft edges are easier to make with soft pastels. Blend the edge of the color with your fingertip or a torchon *bottom*.

Peonies by David Hutter, watercolor *below*. Too many sharp edges with equal focus can give a hard, brittle look to a painting. This sensitively rendered still life, on the other hand, shows how skillful edge handling can both render form and capture atmosphere. Notice how most of the edges are softened, with just a few hard edges being sufficient to bring the picture into focus.

A hard edge gives emphasis to the contour of the jug's handle *right*.

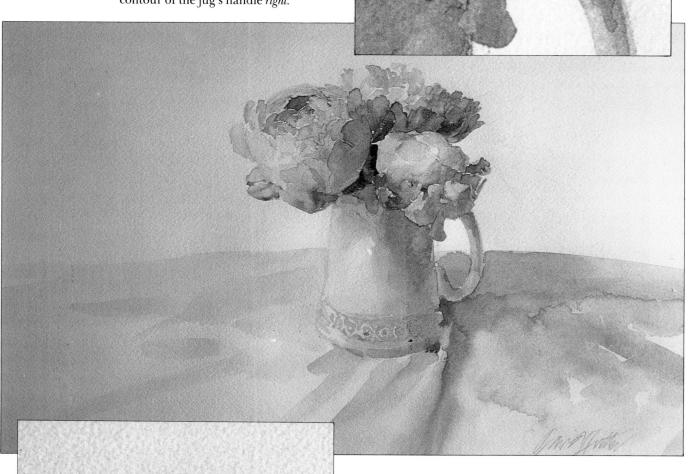

This detail *left* highlights the importance and beauty of a "lost" edge. The artist washes out the color to indicate where strong light strikes the petals.

PORTRAIT OF GEOFF FLETCHER

In this portrait of a young man, artist Tom Coates uses the direct method of painting known as *alla prima* which, loosely translated, means a direct or spontaneous attack. Nothing is left to chance; every stroke of the brush becomes part of the finished statement, and this "knife-edge" approach injects life and energy into the portrait.

Achieving a convincingly three-dimensional impression of your subject depends on your ability to model values. Tom always begins by looking at the subject in terms of large masses of light, halftone and shadow. Having blocked in the large masses, he then proceeds to paint in the smaller details that lie within them. In this way the underlying structure of the subject is firmly established at the outset – and once you've got the structure right, the details fall naturally into place.

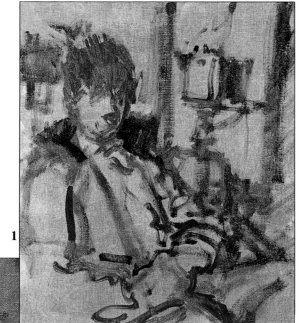

1

2

1 I start by tinting my canvas with a neutral tone, applying the paint with a rag. Using ultramarine and burnt umber, I make a broad brush drawing of the model. I keep the brush moving rapidly over the canvas, trying to get the feel of the subject within the first few minutes. If things don't go well at once, I rub out and begin anew.

2 I roughly block in the broad areas of middle value such as the jacket and the shadow planes of the head. I keep the paint thin and use loose, scrubby strokes – I want to keep my options open in case I decide to alter anything. At this stage I usually turn the painting upside down to test the balance and strength of the composition before proceeding further. In this instance, I've balanced the dominant shape of the model with the smaller shape of his tripod and camera in the background (which also adds interest to the painting because it tells us something about the sitter, who is a photographer).

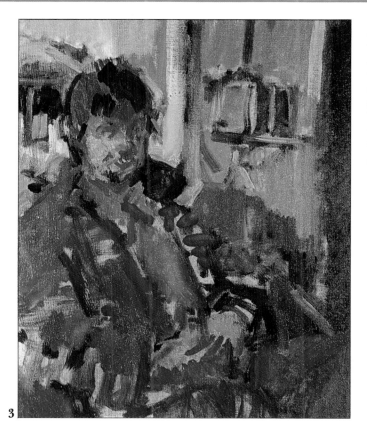

3 Now I start to build up the forms with warm and cool colors. For the warm, light-struck areas of the jacket and trousers, I use a mixture of yellow ocher and cobalt blue. For the cool, shadow areas I use ultramarine instead of cobalt blue. For the flesh tones I use Venetian red, raw umber, raw sienna and white, with more umber and red in the shadow areas.

4 Now I start to strike in some darks, using a strong mixture of ultramarine and raw umber. All the time I'm working with "building blocks" of color and value. Working with large masses allows you to proceed in a natural sequence from broad, sweeping strokes to smaller more precise strokes. At this stage my brushwork is still very loose and fluid; I keep moving around the canvas, restructuring and reproportioning where necessary.

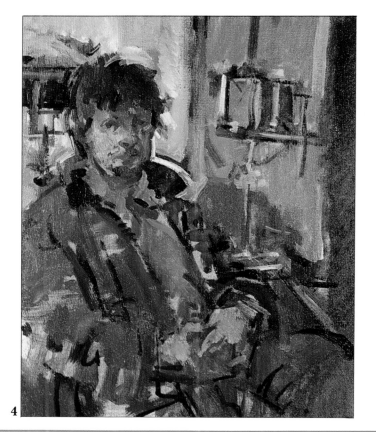

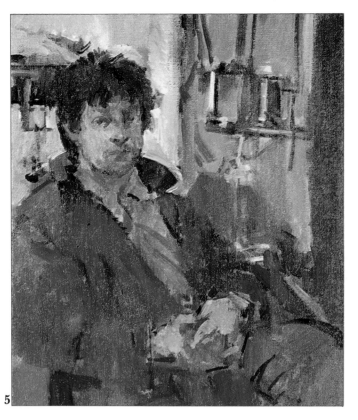

5 Having laid the foundations of the composition, I can confidently build up more color and start to define forms. I brush in the light background with loose mixtures of cerulean blue, yellow ocher and white, and then work on the figure. I work wet-in-wet, melding the shapes together by dragging a large, soft brush over the edges where colors and values meet. By working constantly back and forth between subject and background, I ensure that the two are properly integrated and that there is an overall unity to the composition.

6 Now the picture is beginning to sharpen up. I re-assert the dark values, particularly on the model's jacket. Notice how the dark value of the collar lends emphasis to the face, which is the center of interest.

7 In the final stage *far right* I add the small finishing touches such as the highlights on the jacket, and model the form of the hands more precisely. The painting took me two hours to complete. It could stand as it is, as a fleeting impression of a moment in time, or it could be regarded as an oil sketch on which I might base a more finished painting.

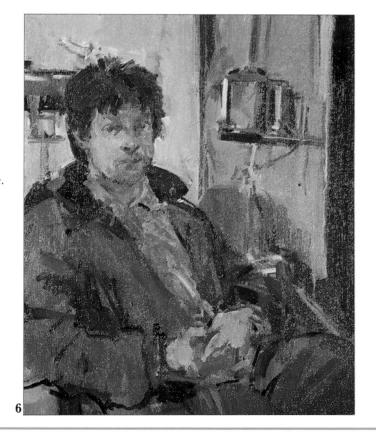

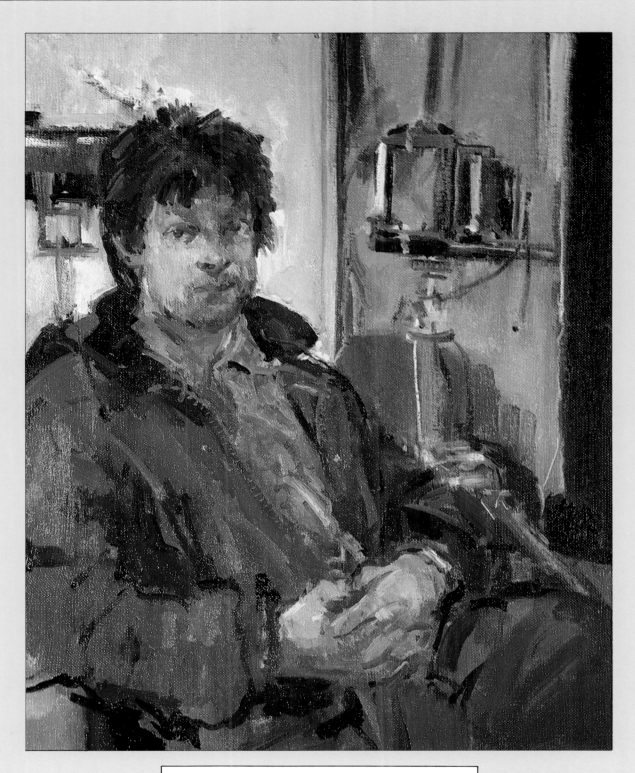

GEOFF FLETCHER, PHOTOGRAPHER

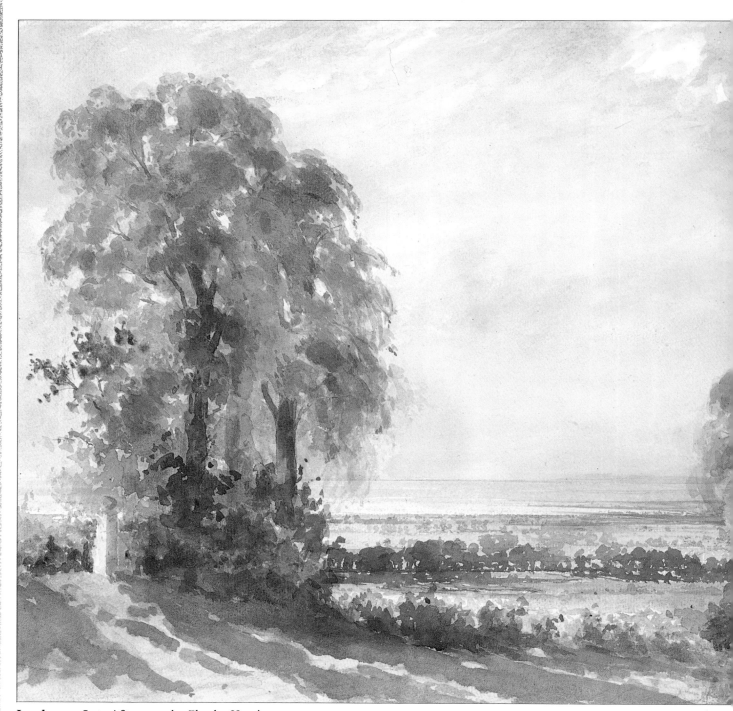

Landscape, Late Afternoon by Charles Harrington

THE ILLUSION OF DEPTH

Perhaps the greatest challenge in landscape painting is that of creating the illusion of space and depth on a flat piece of paper or canvas. The sight of fields, hills and trees stretching away into the hazy distance is a marvelous one, but how can we capture it convincingly in paint?

Simple tricks of linear perspective can work to a certain extent; overlapping one shape in front of another, for example, gives an instant three-dimensional effect, as does the presence of a foreground detail that recedes into the picture, such as a road or fence. But by far the most effective means of improving the quality of depth and distance in a painting is through the use of "aerial perspective." This term, invented by Leonardo da Vinci (1452-1519) describes the phenomenon found in nature whereby dark forms become lighter in the distance but light forms become darker, with the contrasts between values becoming progressively smaller towards the horizon.

This chapter explains how to use value and color to reproduce the effects of aerial perspective and so bring your landscapes to life. In addition, you'll find advice on how to choose the best viewpoint so as to emphasize the feeling of depth and recession. Finally, you'll discover ways to capture the subtle nuances of value and color that lend a feeling of air and atmosphere to portraits, still lifes and indoor scenes.

AERIAL PERSPECTIVE

CREATING DEPTH AND SPACE

The term "aerial perspective" describes an optical illusion caused by the presence of water vapor and tiny particles of dust in the atmosphere, which act almost like a series of invisible veils strung across the landscape. The farther into the distance we can see, the more "veils" we have to look through, which is why colors and forms appear more hazy and indistinct the closer they are to the horizon.

The effects of aerial perspective are most apparent when there are well-defined planes within the subject, such as a mountain range or a series of cliffs jutting out along a shoreline. They can also be seen clearly when dusk approaches, reducing the forms of the land to almost silhouetted shapes that become lighter in value toward the horizon. This makes it easier to see the changes that occur between the foreground, middle distance and far distance. Let's say, for example, that you're standing on a hill, surveying an undulating landscape of tree-covered fields and hills. As your eye travels from the foreground to the horizon, these are the changes you will notice:

◆ **Values become altered** Those objects that are nearest to you are relatively unaffected by atmospheric haze, so you see their values at full strength. In the middle distance, however, some of the strength of the values is lost, due to the intervening atmosphere, and they appear lighter. Way back on the horizon, they are weakest of all, seeming to melt into the pale value of the sky. You will also notice, however, that white objects in the distance become darker, not lighter, in value because they are grayed by the atmosphere.

◆ **Colors become cooler** Atmospheric haze has the same effect on color as it has on value. In the foreground, colors appear bright and warm because they are seen at their fullest intensity. In the middle distance, they lose some of their intensity, become cooler and take on a blue cast. Compare a foreground tree, for instance, with a tree 500 yards away, and notice how the color of the foliage changes from a warm yellow-green to a cooler blue-green. Farther back still, a tree may not look green at all, but a subdued blue-gray.

◆ **Detail and contrast are diminished** Tonal contrasts – say between a light-colored building and the dark shadow it casts – are sharpest and clearest in the foreground. In the middle distance the intervening haze narrows the range of values and causes contrasts to be less marked, while on the horizon there is often no contrast at all – everything is blurred into one pale value. Similarly, texture and detail become less and less defined the farther you get from the foreground.

So, in order to create the illusion of infinite space and depth in our paintings, all we have to do is to reproduce the effects described above. Strong values and warm colors appear to come forward, whereas weak values and cool colors appear to recede into the distance – and it is the contrast between these

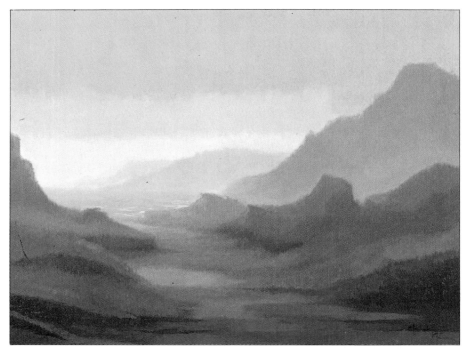

Sea Mist by Clemente Gerez, oil on canvas *left*. Here we see the classic effects of aerial perspective. Values and colors fade gradually toward the horizon, and forms become less definite.

The diagram *above* shows clearly a receding arrangement of overlapping values, which creates a feeling of depth.

values and colors that gives the illusion of distance.

It seems simple, but inexperienced painters often ignore what they see in front of them and put too much color, detail and clarity into their backgrounds. This is because they have fallen into the familiar trap of painting what they know, instead of what they see: they "know" a tree is supposed to be green, so they paint it green, even though it is miles away on the horizon and actually appears blue. The result is always the same – a flat, unconvincing painting with none of the subtle atmospheric qualities that attracted the artist to the subject in the first place.

Winter Sunset, Llwynhir by Diana Armfield, oil on canvas *below*. This landscape conveys a strong impression of space and atmosphere. Notice how the hot colors of the setting sun don't jump forward, but are kept in their place by the stronger value of the large cloud.

The diagram *right* shows how the subtle use of overlapping values draws the eye irresistibly toward the horizon.

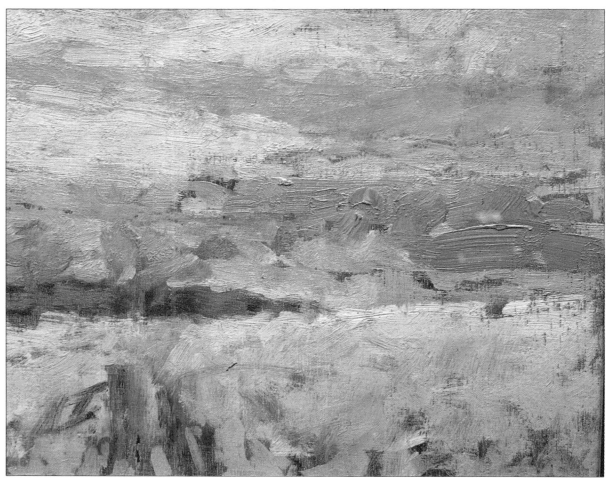

CHOOSING THE BEST VIEWPOINT

GETTING A NEW ANGLE ON THE SUBJECT

Once you have grasped the principles of aerial perspective, the qualities of depth and atmosphere in your paintings will increase tremendously. However, it is equally important to consider the actual composition of your picture, since this can either enhance the feeling of recession or destroy it.

As we have already seen, the way to achieve depth is to divide your picture into distinct areas in terms of distance – the foreground, middle ground and background – and to keep these areas distinct in value. In this respect, your choice of viewpoint becomes a vital consideration; it can make all the difference between a flat, insipid picture and an exciting, effective one.

Let's look first of all at the center of interest, or focal point – the part of the picture to which the viewer's eye is drawn. This does not necessarily have to be in the forefront of the picture just because it *is* the center of interest; indeed by placing it in the distance or middle distance, you will encourage the viewer to "step into" the picture and explore the composition, thereby increasing the impression of distance and depth.

The foreground needs careful thought, too. It should be the strongest of the three planes in the picture, but not so strong that it sets up a barrier between the viewer and the rest of the composition. For this reason, artists such as Camille Corot (1796-1875) included nothing in the foreground of their pictures that was nearer than 200 or 300 yards away from their easels. A slight sketchiness in the immediate foreground is often desirable, especially where the values of the landscape are delicate, as in a misty scene.

On the other hand, a prominent object in the foreground can act as a valuable counterpoint to a more distant center of interest. For example, the overhanging branches of a foreground tree can be used to create a frame within the borders of a picture, through which the viewer looks out across the landscape beyond.

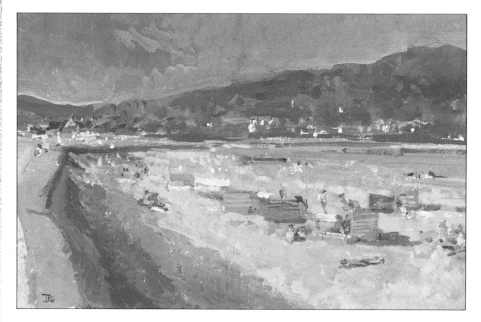

At the beach by Tom Coates, oil on canvas *left*. Here the artist has positioned himself so that the angles of the beach and the background hills form strong directionals that converge in the far distance.

In this lakeside scene *right*, artist Charles Inge was attracted by the elegant shape of the stone bridge in the distance. Unfortunately, the surrounding landscape doesn't contain much in the way of interesting detail and the resulting picture is lacking in depth and atmosphere.

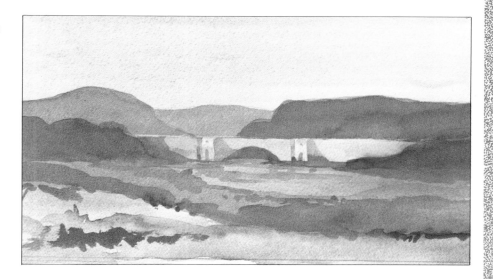

Rather than give up, the artist tries another tack *right*. Here he alters his viewpoint, so that now we can see through the arch of the bridge to the hills beyond. He also includes some trees to the left of the picture. This area of strong value helps to bring the foreground forward, in contrast to the pale, recessive values of the background hills. The sky, too, contains a progression of values from dark to light, which increases the feeling of depth still further.

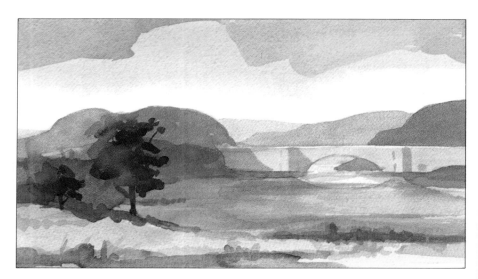

Here's another variation of the same scene *right*. The dark shapes in the immediate foreground, and the overhanging branches in the upper right of the picture, create a "frame" through which we look out at the landscape beyond.

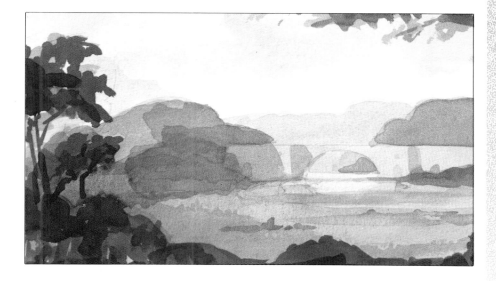

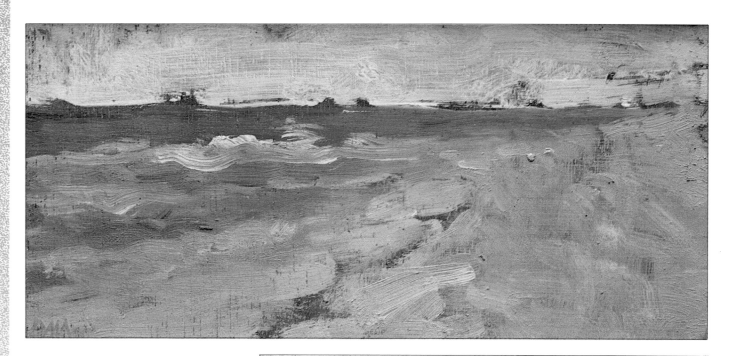

Cottesloe Beach, Perth by Diana Armfield, oil on canvas *above*. In this almost abstract composition, an inspired choice of viewpoint evokes the vastness of the ocean. The high horizon line lends impact to the sweep of the water, which cuts diagonally, like an arrow, through the composition.

The sea presents an interesting reversal of the normal effects of aerial perspective, in that tones become darker toward the horizon, not lighter.

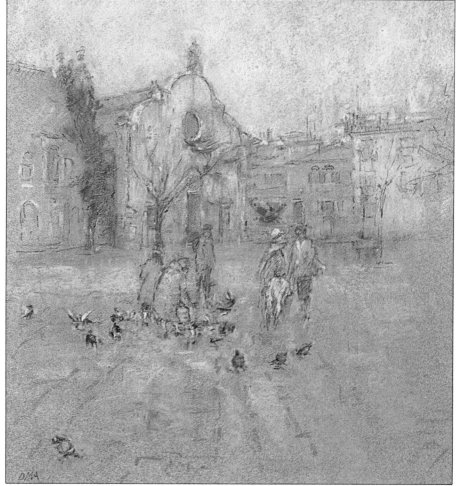

Pigeons in the Campo Bandiera e Moro by Diana Armfield, pastel on paper *right*. The lack of strong detail in the foreground area allows our eye to travel unhindered to the group of figures in the middle distance.

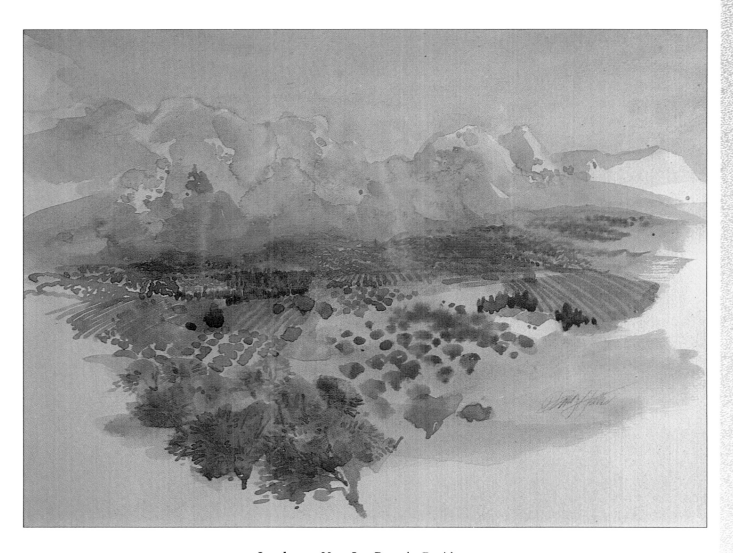

Landscape Near Les Baux by David Hutter, watercolor *above*. In this striking image the artist has chosen a bird's-eye view in which the landscape is rolled out like a map in front of us. Notice how the outer edges of the picture are vignetted; these areas of bare paper seem to pull the eye into the picture and back to the distant mountains.

CONVEYING ATMOSPHERE INDOORS

USING SUBDUED VALUES

The atmosphere present in an indoor scene is much less apparent than in a landscape, but nevertheless we have to be able to capture it if our paintings are to have a sense of three-dimensional reality.

Look up from this page for a few minutes and survey the room around you. Can you spot the differences in value between, say, a dark object placed close to you and a dark object on the other side of the room? Observe closely a group of objects near the window. Because they're directly in the path of the light, the forms are well defined and the values are strongly contrasted. Now look over at the darkest corner of the room: do you see how the values there appear much more muted and details and edges are much softer and less defined?

Having trained your eye to notice the effects of atmosphere on objects, the next stage is to record your observations on paper or canvas. Unfortunately, this is where many amateur painters – and some professionals, too – come unstuck. In their obsession with making things look "real," they portray everything with the same degree of clarity, and build up the painting rather like a jigsaw so that each object is trapped within a rigid outline and thus totally divorced from the atmosphere surrounding it.

In order to create the illusion of depth and atmosphere in a painting, you have to mimic the way the eye actually perceives things. If you hold this book up in front of you and look hard at it, everything in the background appears comparatively out of focus. If you then switch your gaze to the background, the book will appear blurred. The point is that since the human eye does not see everything with equal clarity, there is no reason to paint everything with equal clarity. The way to achieve realism is by emphasizing what is near (by using clear colors and precise outlines) and playing down what is farther away (by softening the contours and modifying the values and colors). This applies even if you are painting a single object, such as a vase of flowers or a portrait head: here, too, the illusion of round, three-dimensional form is achieved by blurring the outlines farthest away and keeping the sharp-focus effects for the immediate foreground.

Don't forget that a good painting or drawing often has a slightly ethereal quality to it. By contrasting hard edges with soft ones, bright colors with muted ones, and sharp detail with sketchiness, you will contribute greatly to the poetry of the painting.

Dog Roses by Diana Armfield, oil on canvas *above*. Even in a study of a single object you need to create an impression of air and space around your subject. Here the outer edges of the leaves and flowers are not hard but softly blended into the background color, particularly at the back of the arrangement. The background itself is painted with broken colors that convey light and movement.

Saskia, Morning by Ken Howard, oil on canvas *right*. This scene has a still, timeless quality reminiscent of the paintings of the Dutch Masters. By using subdued values and colors, and "lost and found" edges, the artist conveys the atmosphere of a room enveloped in the soft shadows of late afternoon.

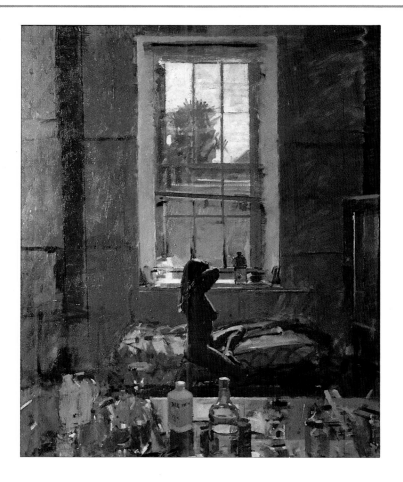

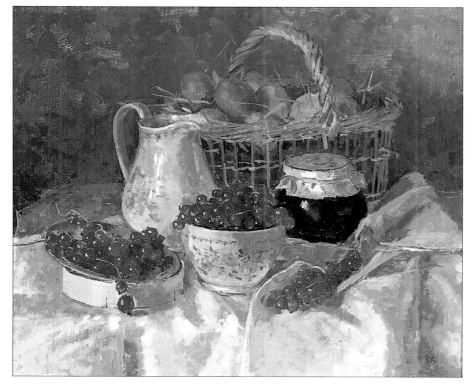

Still Life: Redcurrants and Blackcurrant Jam by Pamela Kay, oil on board, 11½in×13½in *left*. Observe the subtle contrasts that give three-dimensional depth to this still life. The foreground objects, for instance, are clearly stated, whereas the basket of eggs at the back of the group is less defined. The warm red berries bring the foreground closer, while the cool blues in the background are recessive.

The Breakfast Table by Pamela Kay, oil on board, 10½in×8½in *above*. Everyday domestic scenes can provide the inspiration for some wonderful paintings. In this picture the skillful arrangement of lights and darks draws our eye slowly through the composition so that we are aware of the depth and space within the room. The background details are reduced to simple blocks of color, which also helps to create the illusion of receding space.

Miss Julie by Tom Coates, oil on canvas *above*. This painting demonstrates how to achieve that all-important sense of atmosphere in portraits. The colors in the woman's face are closely related to those in the background, so that sitter and background are tied together. Notice also how the edges, particularly those near the back of the head, have been intentionally softened. There is a vibrant, broken quality to the paint that is more suggestive of light and air than an area of flat color.

Project: Altered dimensions

To demonstrate how light and dark values can affect our reading of depth and space, try this experiment. Using ink or felt pen, make a simple line drawing of a room in your own home, as shown. Make three photocopies or carbon copies of your drawing and use these as the basis for a series of studies of the room made at different times of the day. Block in the darks and middle values using a soft medium such as powdered charcoal or graphite, dilute washes of ink, or marker pens.

In each case the linear composition of the room is exactly the same – but you'll be amazed at how the dimensions and perspective of the room can appear to change with different arrangements of light and shadow.

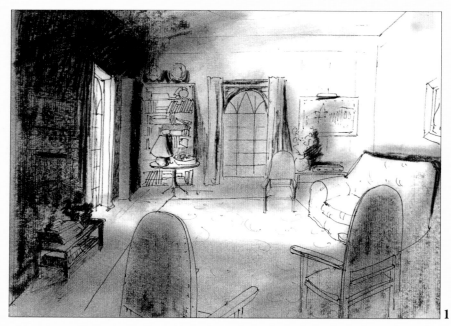

1 Here weak sunlight is coming in from the window at left, creating a horizontal path of light that emphasizes the width of the room. The lack of tonal contrast between foreground and background gives an impression of shallow space.

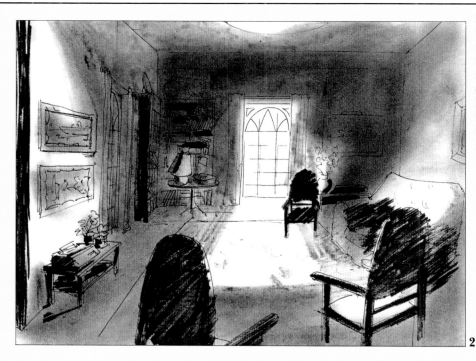

2 A shaft of strong light floods in from the window at back. Now the room looks much longer and narrower, even though the linear composition of the room is exactly the same as in the first drawing. The converging lines of the light pattern on the floor create this illusion of depth, while the strong values in the foreground appear to advance, further stretching the perspective.

3 The same room at night , lit only by a table lamp. With no clear overlaps of light on dark, the spatial sensation is difficult to read and the overall impression is one-dimensional. The sense of depth would be much improved by the addition of another light source in the foreground to create more value contrasts.

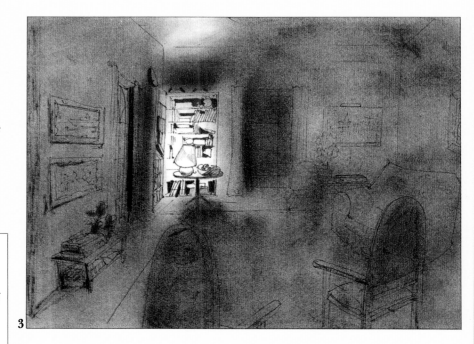

Self-critique

◆ Did you draw your subject under three distinct lighting conditions?

◆ Did you establish a clear pattern of light and shade?

◆ Did you make use of soft edges in the shadow areas and hard edges in the light areas?

◆ Do your three drawings convey three different spatial sensations?

AFTERNOON LANDSCAPE

In this demonstration, artist Roy Herrick uses both linear and aerial perspective to create the illusion of depth in a summer landscape.

1 I start by covering the canvas with a transparent tone of raw sienna, thinned with turpentine. Later on, this warm undertone will show through in places, acting as a foil for the cool greens of the landscape and helping to unify the color scheme.

When the toned ground is dry, I brush in the main patterns of the scene, again with raw sienna. I like to keep this underdrawing loose and flexible; if things are too tight in the early stages it can restrict the flow of your painting in the later stages.

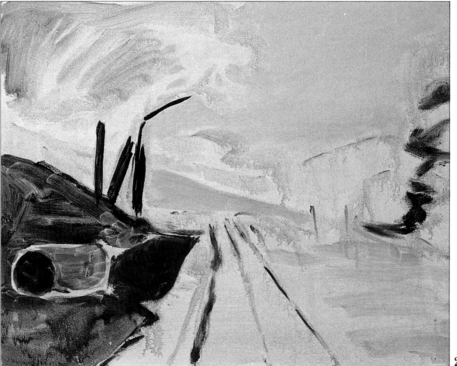

2 One of the problems with painting outdoors is that the light changes all the time, and the shadows move. That's why it's important to block in the main areas of light and shade quickly at the beginning, so that a logical and consistent pattern is established. This way you can carry on painting for hours in the changing light without any worries. Here I've roughed in the shadowy foreground and the light-struck area of the grassy field. For the sky I've used a thin wash of cobalt blue, allowing the warm undertone of the canvas to peep through in places.

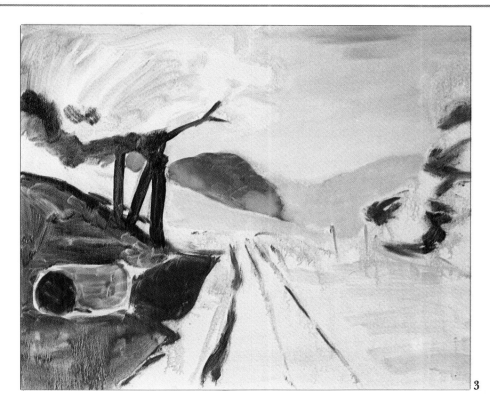

3 Always keep the painting going as a whole, giving equal attention to each area. At this stage I block in the pale colors of the hills in the distance so that I can see how they relate to the foreground elements.

4 For the trees I use various mixtures of yellow ocher, ultramarine and titanium white. Now I start building up a thicker impasto in the foreground, letting the brushmarks indicate the texture of the foliage. Strong contrasts of texture and value bring the foreground elements forward in the picture plane and separate them from the less defined forms in the background.

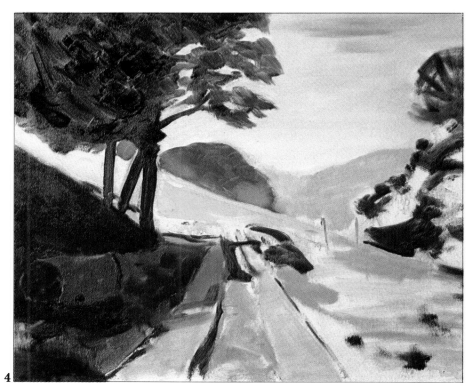

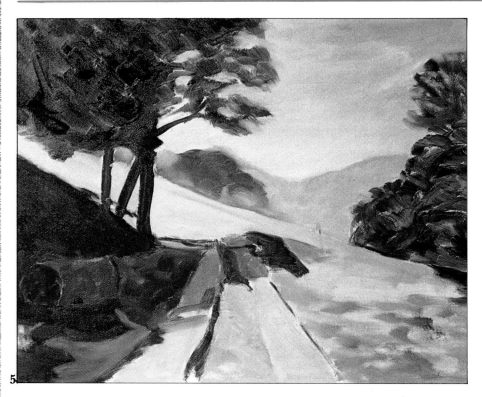

5 At the mid-way stage I stop painting and step back and really scrutinize my painting. I try to forget about the actual content of the scene and look at the painting in purely design terms, asking myself such questions as "have I achieved a convincing sense of depth?" "Is there a good balance of light and dark values?" "Does the painting have a strong center of interest?" In this instance I made the dirt track under the tree slightly darker than it actually was, to reinforce the feeling of bright sunlight elsewhere.

6 Now I strengthen the value contrast between foreground and background. Darkening the trees makes the distant hills appear further away, and also has the effect of accentuating the sunny slope on the left. The value pattern is simple but effective, with a large wedge-shaped area of dark on the left balanced by the smaller dark shape on the right. The detail shows the contrast in treatment between the distant hills and the foreground tree. For the hills I add a lot of white and a touch of blue to my basic green mixture to create a cool, pale tone. The brushwork is smooth, and I blend areas together wet-in-wet to create the effect of distant haze. The foreground tree is much richer in color and stronger in value, with vigorous brushwork creating textural interest.

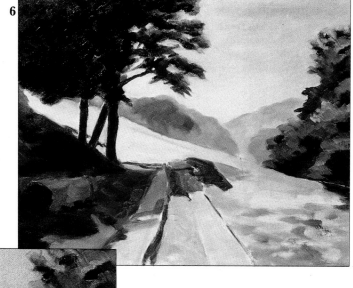

7 In the final stage *right* I indicate light falling through the trees onto the dirt track and dappling the shadows there. I finish off with a few fine details such as the fence and gate on the right.

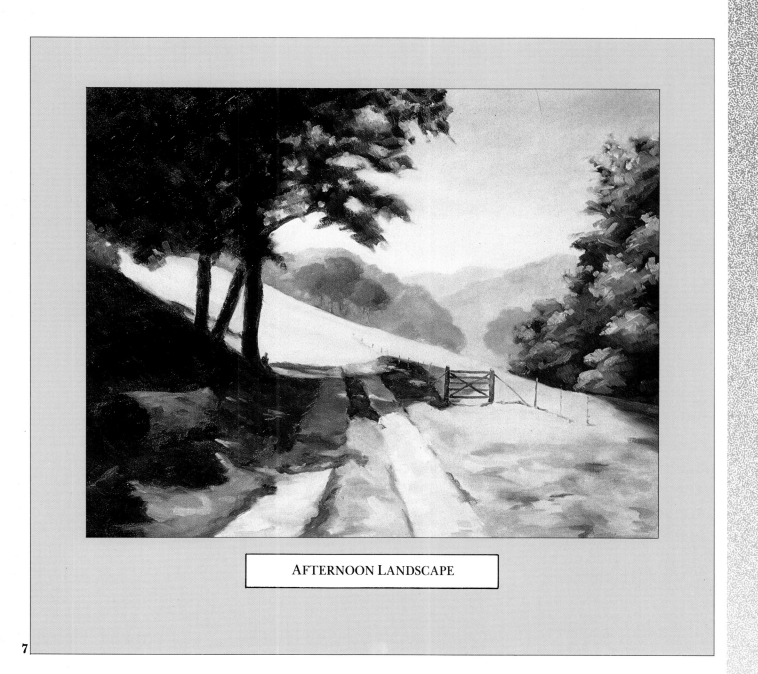

AFTERNOON LANDSCAPE

7

A Day's Fishing by Roy Herrick

·6·

DESIGNING THE PICTURE

Composing a painting means arranging the various elements of the subject so that they present a balanced and pleasing image. Unfortunately this is rarely achieved by merely copying what we see before us. A landscape view that looks "just like a picture" may not, in fact, make a good picture at all as it stands. There may be too many details and colors, for example, that would distract the attention of the viewer and create a confused and muddled composition. As James McNeill Whistler (1834-1903) put it: "seldom does Nature succeed in producing a picture."

The way to solve compositional problems is to *select and simplify*. We must select only those elements that contribute to the overall impact of the scene and reject those that do not. Then we must simplify the composition so as to make it more powerful and direct. In this way, we intensify our experience of the subject so that the viewer, receiving it second-hand, can share in that experience.

This chapter demonstrates how to plan the arrangement of light and dark values so as to give your compositions more impact. Think of the values and colors in your painting as musical notes – by using them in a controlled range, you will produce a result that's not only balanced and harmonious, but also more powerful and intense.

USING AND MAKING A VIEWFINDER

Some lucky people have an instinctive "nose" for a good composition – but for most of us, it requires a good deal of practice and experience. When we look at a complex subject like a landscape, it can be difficult to select a balanced composition from the vast array of shapes and colors.

A cardboard viewfinder is a great help in such cases. By moving around the subject and looking through the viewfinder, you can home in on particular sections of the scene and isolate them from the overall view. The edges of the viewfinder act as a kind of picture frame, helping you to see the physical world in terms of how it might appear on a flat rectangle (or square) of paper or canvas. By placing a definite border around what you select, you'll find it easier to examine the interplay of shapes and masses, and to judge how the contents of the picture relate to the edges of the frame. You may sometimes find that what appeared at first glance to be a good composition reveals unexpected flaws on closer scrutiny. It is far less frustrating to make this discovery now than when the painting is already under way!

As well as being an aid to linear composition, a viewfinder also enables you to see the subject more clearly in terms of areas of light and dark value – a very important part of composition. And during the course of the painting or drawing, the color of the frame itself also comes in useful. I always make my viewfinders from gray or buff-colored cardboard; when held up to the subject, this acts as a convenient middle value against which I can judge the relative lightness or darkness of the shapes within it.

Try looking through a viewfinder, not only at landscapes but also at street scenes, figure groups, interiors and familiar objects around the home. I guarantee you'll begin to discover interesting compositions where you may not have noticed them before.

1 To make a viewfinder all you need is a sheet of gray or buff-colored card, about 6in×8in, a steel ruler, a craft knife and a pencil. Draw a rectangle within the sheet of cardboard, approximately 6in×4in. Alternatively, draw a square if this is the format you intend to use. Carefully cut out the window by holding the craft knife against the edge of the steel rule, keeping the edges crisp.

2 Make sure that the window is centered within the frame, with borders of equal width on all sides.

3 Close one eye and look through the frame. Move the viewfinder up and down, left and right, toward and away from you, or turn it around to try an upright image, until the subject is framed in a pleasing way. You will notice how seemingly ordinary objects can make effective pictures when they are cleverly positioned and isolated from their surroundings. You will probably find several interesting compositions to explore, all from the same source.

Having found a suitable composition remember to make sure that the dimensions of your paper or canvas are in direct proportion to those of your viewfinder, otherwise the composition won't work.

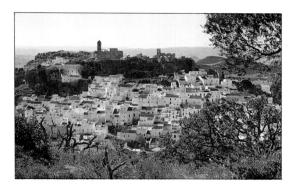

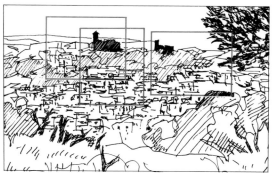

A panoramic view such as this one *above* may appear too daunting to tackle . . . or is it? Using a viewfinder, you could actually make several paintings from this one scene.

Here *above* the artist has used his viewfinder to isolate three small sections of the scene, each of which makes a satisfying composition in its own right.

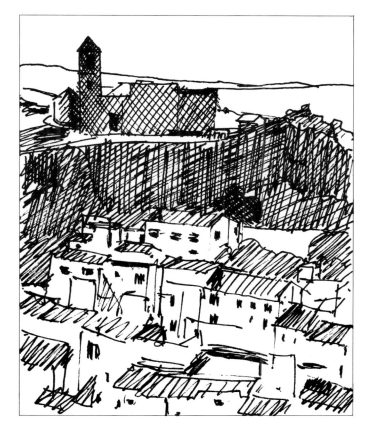

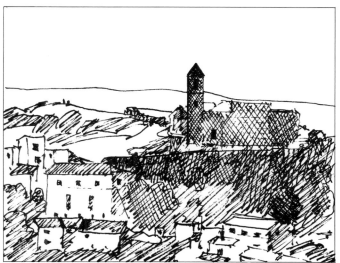

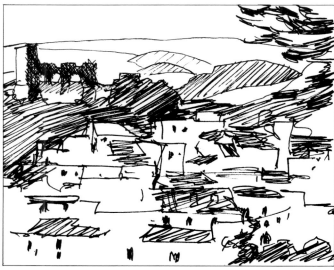

BALANCE AND COUNTER-BALANCE

MANIPULATING VALUES

One of the most important goals in composing a painting is achieving visual balance. In other words, the various elements that make up the image – lines, shapes, colors, values and textures – must be arranged and distributed with care, so as to create a pleasing and harmonious result.

Throughout the centuries, artists and critics have put forward innumerable theories about what makes a successful composition. But it was the ancient Greek philosopher, Plato, who expressed most succinctly what good composition is all about. Plato stated quite simply that "composition consists of observing and depicting diversity within unity." By this he

meant that a picture should contain enough variety to keep the viewer interested, but that this variety must be restrained and organized if we are to avoid confusion.

Plato's observation sums up, in fact, the dilemma that faces us each time we begin composing a painting. For though the human eye is drawn to stability, order and unity, it is also attracted by freedom, diversity and the element of surprise. The challenge for the artist lies in striking the right balance between these opposite attractions.

The most obvious way to achieve balance is through a symmetrical composition, in which elements of similar value, shape and size are used together in almost equal proportions.

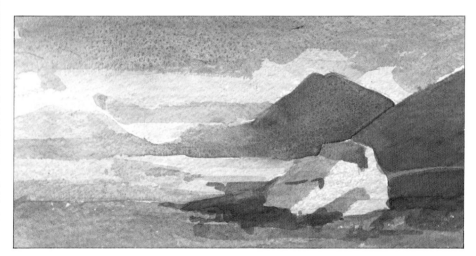

In this illustration *left* we have a landscape in which there is an imbalance between the left and right halves of the composition. The mass of the mountains and rocks on the right has great visual weight, with its strong color and value contrasts, whereas the left half of the picture is virtually empty. The scales drawn beneath demonstrate this imbalance of size and value.

Here *right* the artist tries to restore equilibrium by lightening the values on the right of the picture and including another foreground rock on the left. This is an improvement, but it's a little too symmetrical: both halves of the picture are virtually identical, and there is no main center of interest on which the eye can settle.

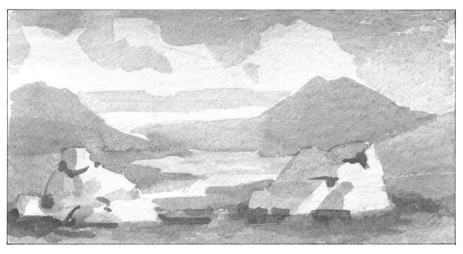

Although at times such a structure may serve a concept well, for most purposes too much symmetry results in a rather static and uninspired design, lacking in the element of diversity that Plato talked about.

For most artists, the way to achieve diversity within unity is to create an asymmetrical composition, in which features that are inherently different but of equal interest are arranged so as to counterbalance one another. An asymmetrical composition succeeds in creating a sense of equilibrium, while at the same time allowing a contrast of shapes, colors and values that lends vitality and interest.

Asymmetrical composition is often compared to a pair of old-fashioned weighing scales, in which a small but heavy metal weight on one side can balance a much larger pile of fruit or vegetables on the other. Think of the shapes and masses within your composition as "weights" to be balanced and counterbalanced until an equilibrium is found. Remember, it is not only size that gives an object visual weight – strong color, shape, texture or value will attract the eye when used as a contrasting element, even in small amounts. For example, a large area of light value can be counterbalanced by a small area of dark value that has more visual weight; and a large area of cool color can be offset by a small amount of intense color that creates a strong focus.

The process of painting a picture is in itself a continual balancing act; one touch of color applied will alter the relationships already established, while the next restores the balance.

This version *below* shows how an asymmetrical composition can create visual interest while, at the same time, retaining balance and unity. The artist has enlarged the distant mountains and included only the foreground rocks on the left. Thus we have a small mass of light value on the left that has enough visual weight to counterbalance the large mass of dark value on the right.

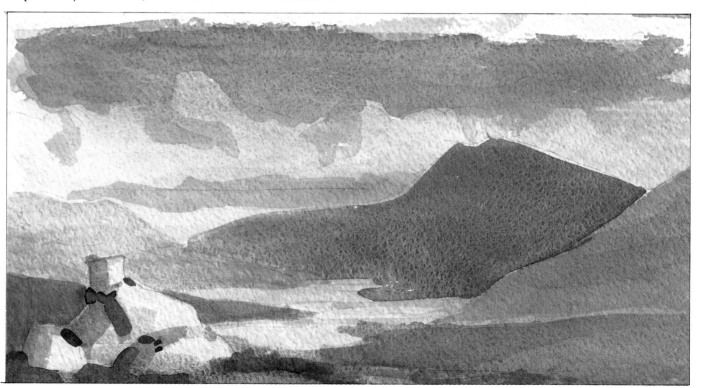

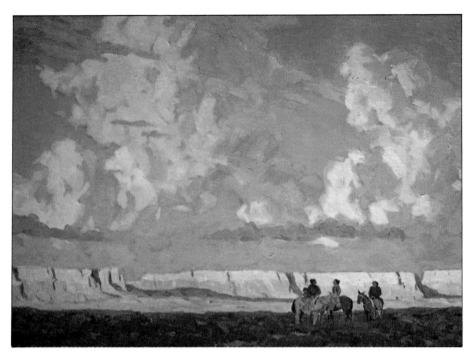

Six o'clock Visit in Colorado Canyon by Gary Michael, oil on canvas, 22in×28in *left*. Here's a classic example of asymmetrical composition. The huge, light mass of cloud that dominates the left side of the composition is stabilized by the contrasting value of the small, but well-placed horseback riders on the right. Our eye is attracted first by this group of figures, which creates arresting light/dark patterns. The thrust and angle of the background shadow propels us to the large cloud, then across and down through the smaller cloud and back again to the center of interest. This circular motion generates a feeling of movement and life.

Parga by Paul Millichip, oil on board, 30in×40in *left*. This simple composition is deceptively well designed. The figure of the boy is placed daringly close to the edge of the frame, but his shadow pulls us back into the picture. Our eye is then caught by the strong diagonal shadows on the wall, which act as a counterpoint to the mainly horizontal composition. Strong value contrasts set up rhythms and tensions that contribute to the dreamlike, enigmatic atmosphere of the scene.

The Friendship Sloop by Stan Perrott, watercolor *above*. The simplest compositions are often the most dramatic. Here the dark-valued, regular forms of the buildings emphasize the sweeping lines of the little boat. The white mast and boom draw the eye inevitably to the two figures, which themselves form a valuable anchoring point to the composition (cover the figures with your index fingers and you'll see what I mean).

CREATING A CENTER OF INTEREST

USE VALUE CONTRASTS AS "EYE-CATCHERS"

On the subject of composition, the nineteenth-century English artist and writer John Ruskin was once asked "Does a picture need a focal point?" His reply was firm: "Indeed it does, just as a meal needs a main dish and a speech a main theme, just as a tune needs a note and a man an aim in life..."

In other words, a picture should have, somewhere within it, one strong center of interest to which the viewer's eye is inexorably drawn – the point which contains the essential message of the picture. Of course, there are many paintings that don't have a center of interest, but these are usually abstract designs in which the artist sacrifices dramatic interest for the overall unity of pattern or texture. In representational painting, on the other hand, the lack of a center of interest leads to an incomplete feeling.

When planning the compositional arrangement of the painting, your first question to yourself should be "what do I want to emphasize, and how should I emphasize it?" For example, in a portrait the center of interest is normally the sitter's face, whose expression conveys his or her personality. In a still life, the center of interest might be a jug of flowers, with the other objects playing a supporting role. Indeed, a picture can be compared to a film or play, in which there may be several actors and various sub-plots, but always one "star" and one main plot, around which everything else revolves.

There are several devices that the artist can use to bring attention to the center of interest, such as placing more detail or texture in that area, or more intense colors, or contrasting shapes. But, to my mind, the most dynamic attention-getter is tonal contrast. It is well known that light areas stimulate the nerve endings in the eye and appear to expand, whereas dark areas absorb light and appear to contract. Therefore, by placing the lightest light and the darkest dark adjacent to each other at the center of interest, you create a visual tension, a "push-pull" sensation that attracts the viewer's eye and holds his or her interest.

More often than not, the subject that you want to paint won't have an obvious focal point – it's up to you to create one. This applies particularly to landscapes and seascapes, in which the sheer magnitude of a panoramic view makes it difficult to focus your attention toward a specific point. When you're looking at the real thing your eyes can happily roam at will over the scene without resting on any particular point, and this won't detract from your enjoyment. But it's a quite different matter when you take all that detail, color and movement and "freeze" it on a small, flat sheet of paper or canvas. For the purposes of good picture-making, a strong focal point is a necessary means of lending interest and a sense of purpose to the scene.

After the Storm by Roy Herrick, oil on canvas *left*. This landscape is simple in execution, but strong value contrasts give it considerable visual impact. The dark tree is silhouetted against a light part of the sky, forming a dramatic focal point. Notice how the light-valued pathway and the yellow field lead the eye to the focal point.

One important thing to remember is that there should never be more than one major center of-interest in a painting. If there is more than one dominant area, the message becomes diluted and the picture loses impact. Even if the picture contains multiple subjects, the composition needs to be carefully controlled so that one subject or area commands more attention than the rest. For example, if a landscape scene includes two foreground trees of equal size, they will compete for attention and you may have to deliberately reduce the size of one tree in order to lend more importance to the other.

This seascape *below left* has few interesting physical features to hold our interest. But the sea and the sky could have been made to look more interesting than they are here; the painting has no obvious focal point, and our eyes dart from one area of the picture to another, unable to settle anywhere in particular.

The same scene *below*, but with one marked improvement. Notice how your attention is caught by the light shape of the cliffs against the dark cloud? The artist has placed the lightest and darkest values next to each other, and this sharp contrast makes an arresting focal point. Now the picture has more meaning, and is more satisfying to look at. The dark foreground wave has a part to play, too. It acts as a counterpoint to the center of interest, while creating a sense of movement that directs our eye toward it.

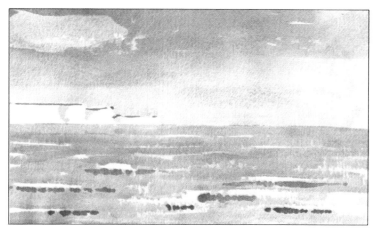

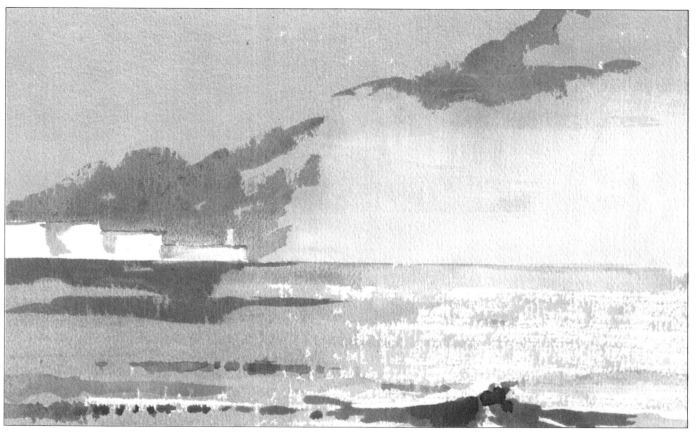

DIRECTING THE EYE

CREATING "LEAD-INS"

When we look at a picture of any kind we instinctively look for a visual pathway to guide us through the composition and make sense of it. If the elements in the picture aren't connected in a pleasing and rhythmical way, we soon lose interest because the picture has a fragmented, incomplete feeling.

The aim of the artist, then, is to lead the viewer's eye into, around and through the picture in a way that's both stimulating and satisfying. The most obvious way to do this is through directional lines, such as those formed by a road, a fence or a stream as it cuts a swathe through the land. Lines like these can be used to lead the eye from the foreground to the background, or to the center of interest, but they can look rather clichéd and overdone unless handled with skill.

A mere suggestion or nuance of linear direction is often all that's needed to gently encourage the viewer to explore the composition. Here, once again, contrasts of color and value can be used to lend rhythm and movement to a composition in a way that is subtle yet compelling.

Directional paths are often created by the nature of the light itself. In a shadowy interior, for example, a shaft of light coming in from a window on the left of the picture will push the eye to the right, producing a momentum that draws the viewer into your work. Think, too, of the patterns caused by sunlight on ripples of water, or of the long shadows cast by trees in the late afternoon.

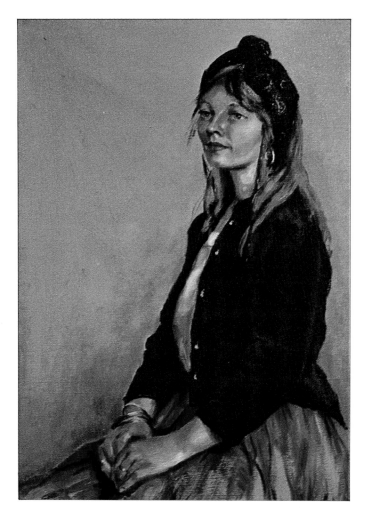

Portrait of Gael by Maurice Armytage, oil on canvas *above*. Note how the light values of the girl's hands, her blouse, and the buttons on her jacket, create visual "stepping stones" that lead the eye upward toward the face.

The Road to Magrié, near Limoux by Diana Armfield, oil on canvas *left*. Here a gently sweeping curve leads the eye through the picture and provides a contrast to the verticals in the foreground.

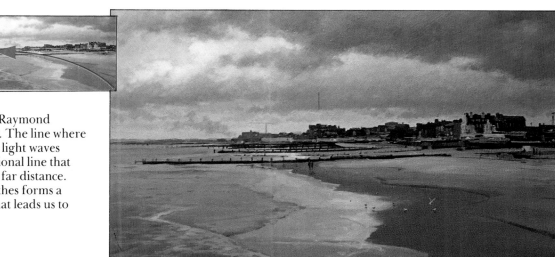

Beach at Low Tide, by Raymond Leech, oil on board *right.* The line where the dark sand meets the light waves creates a forceful directional line that propels us back into the far distance. The line of wooden staithes forms a secondary directional that leads us to the buildings at left.

British Tramp at Sea, Moonlight by Charles Longbotham *above.* Note how the dark values in the sky and sea set up a swirling, vortex-like rhythm that heightens the tension and drama of the scene.

SHAPES AND SILHOUETTES

DESIGNING WITH SHAPES

When we look at a picture, it is the broad pattern of light and dark masses that first strikes the eye, giving us an instant summary of the picture's mood and content. If this pattern has enough impact, it will stop viewers in their tracks and encourage them to look more closely; if the pattern is weak, they may well give the picture no more than a passing glance.

Looking for silhouetted images is a good way to develop your awareness of the patterns created by the contrast of light and dark shapes. By cutting out distracting details of form and color, a silhouette concentrates your attention on the shape or outline of the subject and makes it easier to "read." It also shows clearly how the positive and negative shapes within the borders of the picture balance each other.

An understanding of the interaction of positive and negative shapes is vital to the successful design of a picture, yet this is an aspect of composition that is often ignored or misunderstood. Perhaps this is because, when painting a scene or a group of objects, we tend to concentrate on the task of interpreting the solid, three-dimensional appearance of what we are painting. But a picture must also work on another level – as a two-dimensional design of interlocking shapes that relate to each other in a way that's both balanced and interesting. The positive shapes of the objects in a picture are important – but so too are the negative shapes created by the spaces around and between those objects. The background of a portrait, for example, is not just an area where nothing happens. It can be a very definite shape that can be used as a counterbalance to the shapes made by the sitter's face and hair, or the angle of the shoulders. The composition of a picture is much more telling if the positive and negative shapes are well thought out, rather like the notes in music that are grouped together to form a harmonious melody. Look at the images on these pages: the positive shapes of the silhouettes are easy to recognize, but you'll notice also how interesting are the negative shapes surrounding them.

Wheelbarrow by Leslie Worth, watercolor *above*. Contrasts of value and color make sure you gain the attention of the viewer. Here the artist has cut out all extraneous detail and reduced the image to its simplest terms. Strong value contrasts accentuate the striking shapes created by the wheelbarrow and broom.

Porth-en-Alls by Lucy Willis, etching *right*. Good silhouette material can be found in the early morning and late afternoon. Here the sun, low on the horizon, reflects off the wet sand and throws the figures into silhouette, creating a rhythmical pattern of dark-against-light.

Project: Seeing things in black and white

To train your eye to look for interesting positive and negative shapes, try making cut-paper silhouettes. Select a view with some good light-and-dark contrasts, such as trees against the sky or, as below, boats on water. Alternatively, base your collage on a photograph from a book or magazine. Squint strongly to reduce all the shapes in the image to either light or dark. Draw outlines of the dark shapes on black paper, cut them out, and arrange them on a sheet of white paper just as they appear in your chosen scene or photograph. Without distracting color or detail, these black and white shapes are easy to read in design terms. Try moving the shapes around on the paper, adding further shapes or subtracting existing ones, to see if you can come up with a more interesting composition.

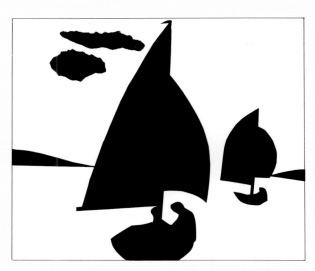

This composition *above* is too safe and predictable. The mast of the foreground boat cuts the image in two, and there are virtually no overlapping forms to interest the eye.

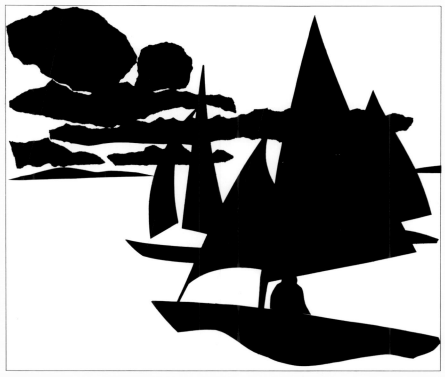

A similar scene *above*, but with a marked improvement in design. The overlapping shapes of the sails form a rhythmic pattern that is offset by the horizontal shapes of the clouds and boat hulls. And the shapes *between* the objects are interesting in their own right.

Self-critique
◆ Did you try out more than one compositional arrangement?

◆ Did you use overlapping shapes?

◆ Did you use both cut and torn shapes, to create a variety in types of edges?

◆ Looking at your picture, are the positive and negative areas varied in shape and size?

MASSING TONES

SELECT AND SIMPLIFY

From our experiments with silhouettes, we've learned a lot about designing with those "big shapes" that give a picture its initial impact. Now, let's take a look at how light and shadow shapes can be tied together to create powerful connecting elements that give unity to the composition. This process, known as "massing", involves merging adjoining shapes of similar value, that are not focal points, into one overall value.

When light shines on a complex subject, a vast range of values is created, which can cause confusion and frustration for the artist struggling to make sense of it all. Don't make the mistake of rendering every little piece of light and shadow you can see, in the hope of producing a faithful copy of the subject. This will only lead to a composition that looks distracted and over-busy. Instead, aim to simplify the light and shadow shapes as much as possible to produce a clear statement and a cohesive and unified pattern of lights and darks. Look for opportunities to eliminate the boundaries between shapes by letting darks merge with darks, lights with lights, and middle values with middle values. By "tying" small shapes together

into bigger shapes you create a unified, interlocking design that gives the picture far greater impact.

But how do we set about massing values without losing the vitality of the subject? Surely reducing the range of values will result in a flattened and simplified image with no subtlety or mystery? The answer lies in working *from the general to the particular*. In other words, begin by establishing the main shapes of light and dark, and then work on the subtle variations of value within those main shapes. Establishing the big value areas first will give you a sense of direction, and you'll find it easier to "sculpt" out of those areas just the right amount of detail to give a realistic effect, without losing any of the subtlety that makes a painting intriguing to look at.

The method that I generally use is as follows: first, I take a long, hard look at my subject, half-closing my eyes to reduce the jumble of values to simple shapes of light and dark. At this stage I make a rough value sketch in pencil, to clarify the shapes in my mind. The sketch also allows me to see whether the shapes of light and dark work well together, forming a balanced but lively arrangement. If not, I might adjust the com-

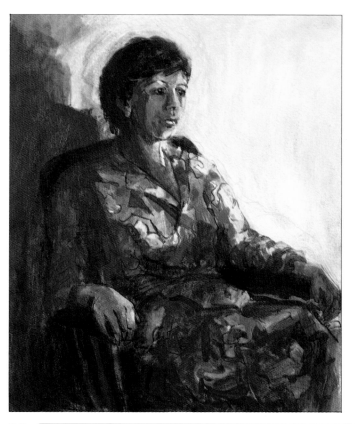

Fragmented tones and a degree of emphasis that is the same for each of the sitter's features gives the portrait *above* a stilted, unrealistic feel. Massing the tonal values of the subject, drawing the viewer's attention to the illuminated areas, creates a more believable, satisfying result *left*.

position by introducing a shadow here, or lightening an area there.

At the painting stage, I begin by blocking in all the shadows with the same value – generally somewhere between the palest and darkest shadows. Then I do the same for the lights. Having established the main value pattern, I can now work up from the general to the particular, introducing darker and lighter values where necessary within the main shapes. If I'm working in oils this is quite easy, since the paint stays wet long enough to be "pushed around" on the canvas and values can be blended into one another with no ugly hard edges. Only in the final stages do I introduce the sharp accents, highlights and reflected lights that make everything else click into place. This method is rather like the way a sculptor works – starting with the large masses and gradually carving out the finer details. I can thus avoid the busyness and confusion that arises when an artist works in "piecemeal" fashion, concentrating on one small area and then moving on to the next.

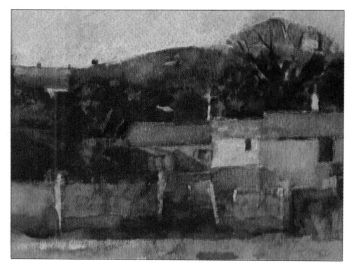

Gees Farm by Christa Gaa, watercolor and gouache *above*. Another fine example of how massing values can lend strength and directness to a composition. The simple shapes of the sky and the cottages are accented by the large, dark-valued mass of trees and foliage.

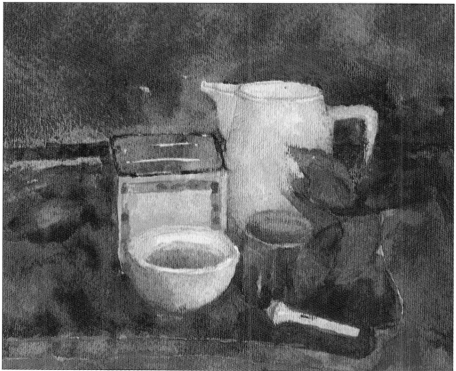

The Blue Jug by Christa Gaa, watercolor and gouache *above*. The grouping of the objects in this still life is elegantly designed. The dark shapes merge into the background values, allowing the light shapes to really sing.

DESIGNING WITH SHADOWS

SEARCHING OUT DYNAMIC PATTERNS

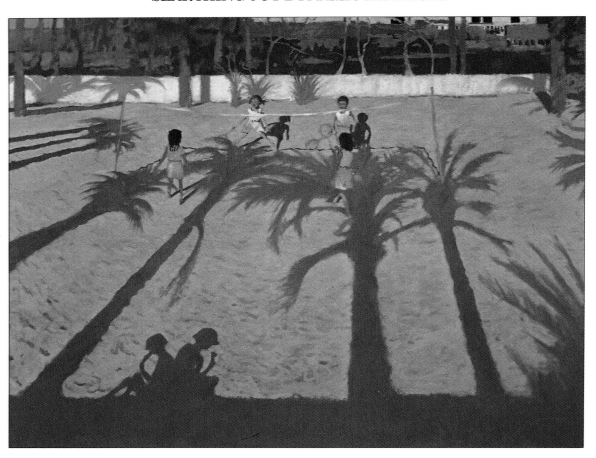

Shadow areas and cast shadows create exciting light/dark patterns that can be used to add interest to a picture and strengthen its composition. Take a group of trees in a landscape, for example. On a dull, overcast day when no shadows are cast, they would create a somewhat flat and uninteresting image. But on a sunny day in late afternoon, those same trees will cast long shadows that flow across the ground, emphasizing the forms of the land and creating directional lines that connect one part of the picture to another.

Interesting shadows happen all the time if we know how to look for them. A dull brick wall is instantly transformed by the dappled shadows cast by a nearby tree; the shadow of a houseplant falling across the breakfast table might spark off an idea for a still life composition.

Learn to use the design potential of shadows in forming rhythms and connections that help to unify the elements in your compositions. When you're arranging a still life set-up, for instance, try to position the light source so that it comes in from one side and creates strong shadows. These shadows play a vital part in giving life and energy to a group of inanimate objects that might otherwise appear static. Cast shadows not only give weight and solidity to the objects, they also create a tonal "pathway" through the composition that the eye naturally follows. In addition, these tonal shapes echo the shapes of the objects themselves and give a pleasing sense of rhythm and unity to the picture.

Outdoors, of course, you cannot control the lighting. But you can help yourself by choosing the right time to paint. Early morning and late afternoon produce the most interesting shadows, whereas at midday when the sun is high in the sky there is a very little shadow around. Viewpoint is important, too. Having found a suitable spot to paint, move around it and examine it from different angles, looking out for the most interesting arrangement of shadows (a cardboard viewfinder comes in useful here). And don't forget, as an artist you have license to subtly move, distort or darken a shadow for dramatic effect or to improve the design quality of your picture.

The Badminton Match, Tenerife by Andrew Macara, oil on board *left*. Here the artist has harnessed the design possibilities of cast shadows to create an exciting and unusual composition. The palm tree shadows lead the eye forcibly to the group of children playing badminton, and here our interest is held by the interaction of light and dark shapes. There's a touch of humor, too, in the shadows of the two boys eating ice cream.

Afternoon in the Garden by Lucy Willis, watercolor *right*. This composition is charmingly informal, but it contains subtle rhythms and connections that cleverly tie it together. See how the striped lines of the blanket and the criss-cross pattern of cast shadows are echoed in the horizontal and criss-cross bars of the chair frame.

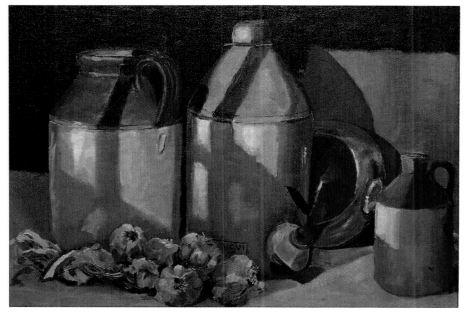

Still Life with Garlic by Roy Herrick, oil on canvas *left*. Sunlight slanting down from a high window lends a touch of poetry to this group of earthenware bottles. Without the strong shadows the painting would have been much less interesting.

Project: Lighting for effect

Learn to use the design potential of shadows and cast shadows in your compositions. Dark shadow shapes act as unifiers, tying together the various elements of a picture. Experiment by setting up a simple still life in a darkened room and directing a moveable light source onto it. Make several sketches of the group, each time altering the angle and direction of the light source. Then compare your sketches and decide which one is best in terms of light/dark design.

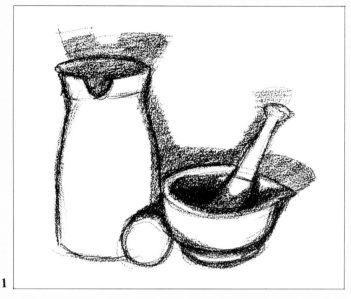

1

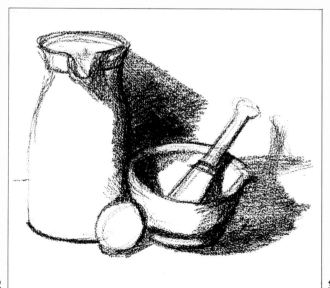

2

3

1 A strong light coming from directly in front casts deep shadows immediately behind the group. There are no cast shadows to anchor the objects to the surface on which they stand; no shape-enriching shadows on the objects themselves; and the light/dark pattern is uninteresting.

2 A strong side light creates better cast shadows, but the divisions between light and shade are too harsh. The narrow strip of shadow running down the side of the tall jug is a distracting element that cuts the composition in two.

3 Light coming from a three-quarter angle creates an intricate pattern of light and shade that greatly enriches the composition. The shadow cast by the bowl travels over the egg and around the base of the jug, emphasizing their forms and tying the elements together.

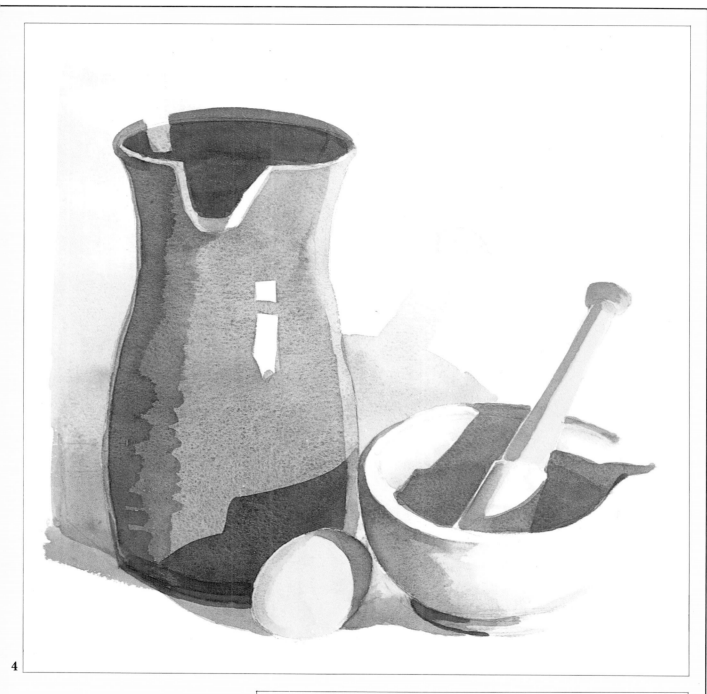

4

4 A watercolor study based on the final sketch.

Self-critique

◆ Did you light your subject from a variety of different angles?

◆ Do the forms in your drawings look solid and three-dimensional?

◆ Were you able to unify elements in your picture through light and shadow shapes?

COUNTERCHANGE

PLAYING THE LIGHT AND DARK NOTES

Another way of using value patterns to create lively pictures is through "counterchange" – the placing of light shapes against dark, and dark shapes against light. For example, see how Bert Wright has placed light figures against the dark buildings, and dark figures against the light buildings in his painting *Dawn on the Ganges* (below). These light/dark reversals set up interesting contrasts for the viewer to explore, and they also lend movement and rhythm to the scene as our eye jumps from light value to dark and from dark value to light.

The principle of counterchange is demonstrated often in nature, and a lot can be learned by observing its effects. I love to stand on a hillside and survey the landscape on a bright windy day when the clouds throw moving shadows over the forms of the landscape. At one moment there's a gap in the clouds and the sun falls like a spotlight on a distant field, revealing it as a light shape contrasted against a dark background of cloud shadow. At the same instant, a passing cloud throws a deep shadow over a nearby group of trees, that appear as dark shapes against the lighter value of the sky. In another instant, the situation might be reversed as the wind blows the clouds in another direction. The effect of all this is mesmerizing – even the most ordinary scene becomes alive and vibrant, transformed by the magic of light.

You can also see counterchange at work in many great paintings, both past and present. The Dutch masters, in parti-

cular, used it to stunning effect in their paintings of domestic interiors, in which a semi-silhouetted figure might be placed against the light of a window that in turn is surrounded by a wall in shadow. If you have any books at home that contain reproductions of great paintings, it is worth studying them to see how the artists used counterchange as a compositional element. Try making small pencil sketches in which you reduce the elements in the picture to simple shapes of black and white. This will enable you to analyze the light/dark pattern more clearly.

Train your eye to be more aware of sharp contrasts in value, and exploit them in your paintings. If necessary, you may have to alter adjacent values yourself in the interests of a more dynamic composition. A light-colored building, for instance, will look more dramatic if you darken the value of the sky behind it, or include some invented dark-valued trees beside it. Artistic licence is often a must in the interest of creating better pictures!

Of course, you will have to judge for yourself how sharp these contrasts need to be; remember that the greatest contrast should be reserved for the center of interest, while keeping the contrasts elsewhere in the painting relatively subdued. Counterchange works effectively only if used in a subtle way, to create movement and rhythm in the picture. Don't let it become a formula for creating compositions that are slick and mannered.

Dawn on the Ganges by Bert Wright, watercolor. There's plenty for the eye to explore in this lovely painting. The rhythmic patterns of light on dark, dark on light are like the notes on a musical scale.

Notice the silhouetted figure placed against the light building and the sunlit figure against the dark street.

The sunlit trees are shown against a dark part of the sky. The building and the dark trees on the right also help with the counterchange.

GATHERING RAINCLOUDS

When planning a landscape composition, remember that you don't have to slavishly copy everything you see just because it's there. In this demonstration, artist Raymond Leech takes a less-than-inspiring landscape scene and, by re-arranging things a little, turns it into an attractive painting.

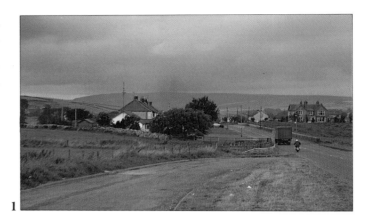

1 The actual view has potential – I like the way the houses on the left are nestled among the trees, and the gathering rain clouds add a note of drama. The problems include a general lack of value contrast, too much busy detail, and a rather clumsy shape in the foreground right, where the two roads intersect.

2 My first step is to make a value sketch of the scene in which I iron out these problems and establish a stronger, more coherent image. I alter the shape of the road so that it creates a pleasant S-curve that leads the eye through to the focal point of the picture – the group of houses and trees over on the left. Also, I simplify distracting details such as telegraph poles and architectural features, and I introduce more tonal contrast between the sky and the land.

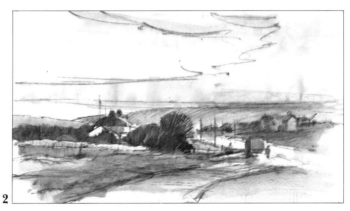

3 My support is a hardboard panel, which I prime with a textured emulsion paint. It plays havoc with my brushes, but I find the finished effect well worth it because, when dry, the rough-textured finish lends a subtle sense of movement and helps break up the color.

When the priming is dry I apply a transparent toned ground all over the support, to establish the color key. For this I use a dilute solution of raw sienna mixed with plenty of turpentine and rubbed onto the panel with a rag.

With a softhair brush and a thin mixture of cobalt blue and burnt sienna, I outline the main shapes and contours in the composition.

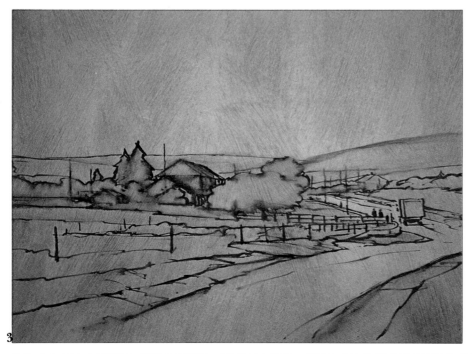

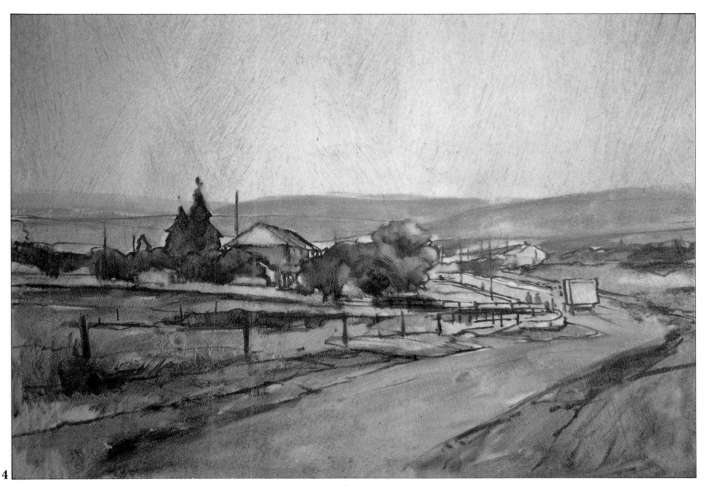

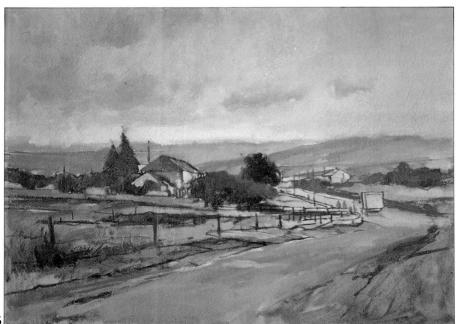

4 Using thin washes of cobalt blue and burnt sienna, I make a rough underpainting to establish the main masses of light, middle and dark value, and of warm and cool color. This stage is important, because it gives me a firm foundation from which I can build up the succeeding colors.

5 I paint the sky and distant hills using mixtures of cobalt blue, cobalt violet and titanium white. The road is wet and reflects some of the sky color, introducing a pleasing note of harmony to the scheme.

6

6 Throughout the painting process I am constantly stepping back from my canvas to observe both the painting and the scene itself through half-closed eyes. This way I can check that the balance of light and dark masses is shaping up OK. At this stage I decide to take out the truck on the bend in the road. It is too obtrusive, and prevents the eye from moving freely forward into the picture.

Now I begin to thicken the impasto of my paint and to strengthen the darks in the trees and buildings, using the sky colors darkened with raw sienna. This deeper value has an immediate effect of pushing the blue hills way back into the distance, thus strengthening the illusion of depth and space. For the grassy fields I use a loose mixture of yellow ocher and raw sienna applied with broken brushstrokes to give variety to the greens.

The detail shows how the main focal point of the picture is established by juxtaposing the light value of the building with the dark values of the surrounding trees.

7 In the final stage *right* I strengthen the light values to brighten the scene a little. I introduce touches of yellow ocher mixed with white into the sky and fields, and finish off by flicking in a few white daisies to enliven the foreground.

7

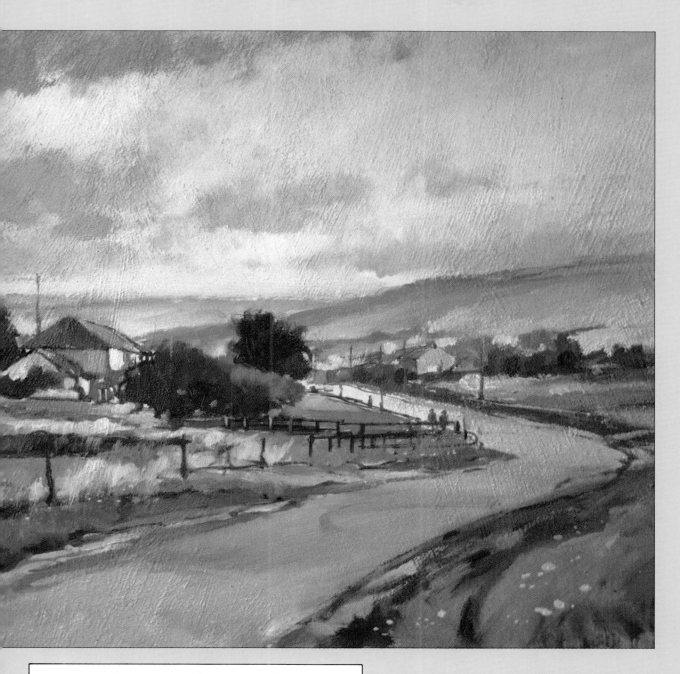

GATHERING RAINCLOUDS

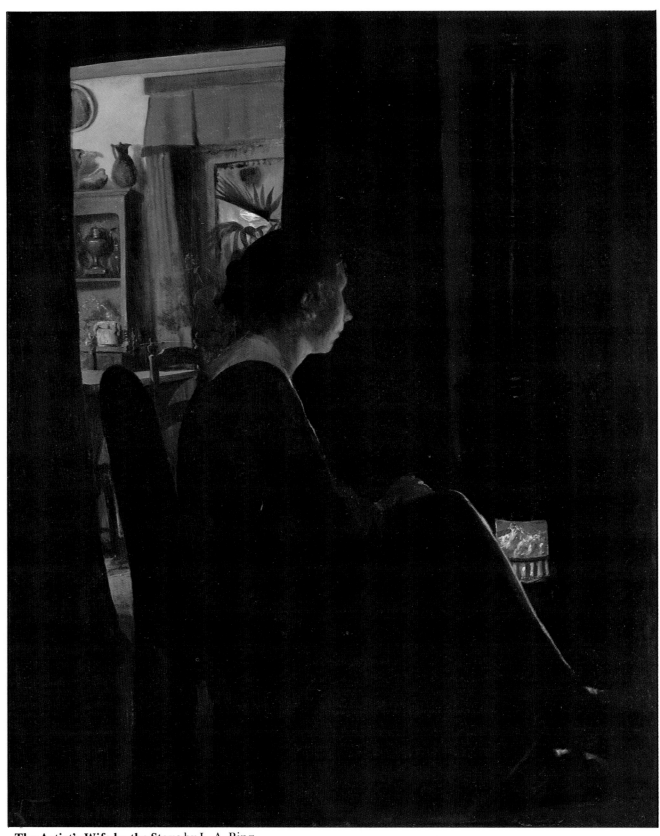

The Artist's Wife by the Stove by L. A. Ring

·7·

CREATING MOOD

So far we've looked at ways of using tonal values to describe the *physical* aspects of what we see – in rendering the character and solidity of objects and the nearness and farness of things, for example. But the *emotional* content of a picture is every bit as important, if not more so. Mood, atmosphere, a certain intangible quality conveyed by the way light falls on a subject – these combine to create "the spell that charges the commonplace with beauty," to quote from the great British photographer Bill Brandt.

Here, once again, tonal values play a major role in creating the mood you want to convey in your pictures. There is a strong connection between the value range in a painting and the mood it conveys; a preponderance of dark values gives a somber or mysterious atmosphere, wheras light values create a lively or cheerful impression.

The way light and dark values are arranged and distributed can also have an influence on the emotional impact of a painting. For example, dark values in the lower half of the painting convey a feeling of strength and stability; but if the dark values occupy the upper half of the composition, as in a storm scene, the mood alters radically, becoming somber and threatening.

This chapter explores the many ways in which tonal values can be organized and used as a means of expression. You'll learn how to key tonal values to convey a particular mood; how to capture the atmospheric effects of light, both indoors and out; how to use light to create mood in portraits; and how to exploit the magic and mystery of shadows in creating powerful and compelling images.

KEYING YOUR VALUES

CREATE EMOTIONAL IMPACT

To express it simply, the term "key" refers to the overall lightness or darkness of a particular painting. A painting of a dimly lit interior, for instance, could be termed "low key" because it would contain mainly dark values. A cornfield on a summer day, on the other hand, would be the subject of a "high key" painting, containing mainly light values.

Where many amateur artists go wrong is in not understanding the importance of using a limited range of values to express a particular mood and to give greater power and directness to their paintings. When a painting contains too many different values, it becomes rather spotty and confused, and furthermore, the emotional message becomes dissipated. It is far better to use a limited range of values – certainly no more than five – and exploit them to the full.

In Chapter 6 I drew an analogy between the values in a painting and the notes in music, and how they should be used in a controlled range in order to achieve pictorial harmony. To take the analogy a stage further, we can compare the whole range of values of a painting with the key of a piece of music, and the way in that they both create a particular mood.

Music that is composed mainly of high-key notes sounds either light and cheerful or poignant and romantic, depending on the rhythm of the piece. Low-key notes, on the other hand, produce a more somber, melancholy sound. These high notes and low notes are the equivalent of light and dark values in a painting: light values will create a cheerful and optimistic mood, or a soft and romantic one, whereas dark values will create a sense of drama or mystery.

Look at any successful painting and you'll see immediately that it has a good key – there is a unity, a feeling of strength and solidity that stems from the perfect harmony of values and colors. You'll notice too how the artist has deliberately orchestrated the values to underline the mood he or she wishes to convey. Think of the Impressionists, for example, whose high-key paintings capture perfectly the brilliance of sunshine and the heady warmth of a summer day. At the other end of the scale there are the low-key paintings of the great Dutch masters of the seventeenth century – people such as Rembrandt (1606-69), Vermeer (1632-75) and Pieter de Hooch (b. 1629) – in whose portraits and domestic interiors the tranquil atmosphere is conveyed exquisitely through the use of muted darks offset by a few telling areas of soft light.

So by now you can see that values play a vital role in establishing the overall atmosphere or mood of a picture, no matter what your subject is.

Rural Landscape by Oliver Warman, oil on board *right.* This is an example of how tonal key can be used to express something more than just the physical appearance of things. Here the artist has deliberately keyed his colors very high (notice the mauves and pinks in the foreground shadow). Somehow we are made to feel the intense heat and the blinding light of a hot day in high summer.

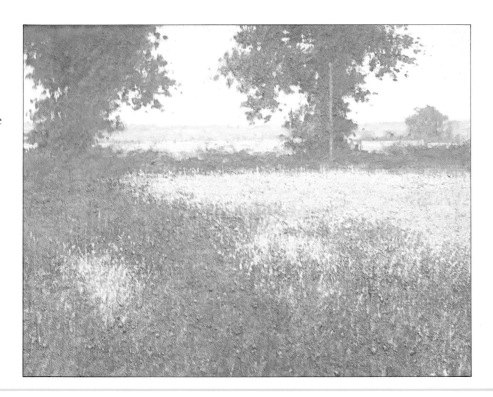

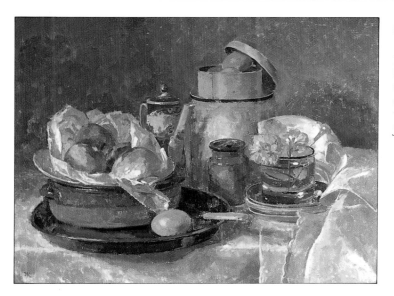

Still Life with Bread Rolls by Pamela Kay, oil on board *left*. Middle value paintings have a quiet harmony that makes them easy on the eye. The beauty of this painting lies in its simple arrangement of neutral colors, against which the pink flowers sparkle like tiny jewels.

Saskia at St Clements Studio by Ken Howard, oil on canvas *right*. A low key painting, in which all the colors are toned down, can create many moods, ranging from dramatic to melancholy. For this interior scene the artist uses a somber, almost monocromatic palette. The soft backlight imbues the scene with an air of stillness and calm.

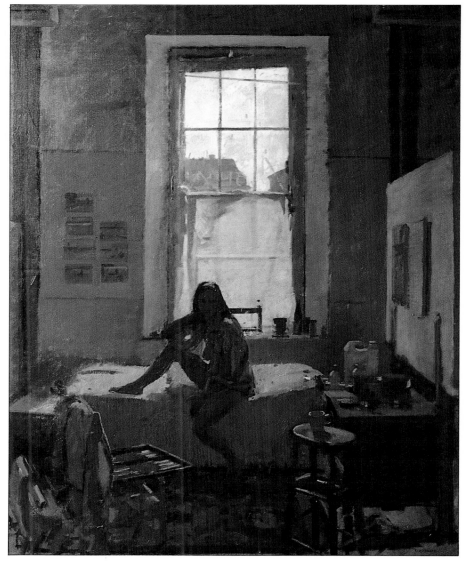

HIGH-KEY PAINTINGS

PALE VALUES FOR DELICATE EFFECTS

I n a high-key painting most of the colors are in the light-to-middle value range, and there are no sharp contrasts of value. This creates a slightly hazy, atmospheric effect that is ideal for expressing qualities such as delicacy, tenderness, softness, fragility or purity.

To create a high-key painting, use pale, gentle colors mixed with a lot of white, and work wet-in-wet so that one color blends softly into another with no abrupt change in value. To keep the colors lively and luminous, don't overmix them on the palette; it's far better to do as the Impressionists did and use small strokes and dabs of broken color (see right) which blend in the viewer's eye while still retaining their vibrancy.

Indeed, it was the Impressionists – notably Claude Monet (1840-1926), Edgar Degas (1834-1917), Alfred Sisley (1839-99) and Camille Pissarro (1831-1903) – who were perhaps the **greatest exponents of high-key painting. They were fascinated** by light and the way it affects the appearance of objects, and their canvases consist almost entirely of high-key colors that capture not only the impression of shimmering light but also

the mood of exuberance that we all experience when the sun is shining.

So what kind of subjects are suited to the high-key treatment? Let's take a portrait subject to start off with. Suppose you want to paint a portrait of a small child, or a mother nursing her baby, or a pretty young girl. What makes these subjects so attractive is their qualities of youth, innocence, gentleness and grace – qualities that might be lost if you used too many dark values in the painting. Soft, warm, gentle colors, on the other hand, are more in keeping with the emotional spirit of the subject.

Of course I am not presenting this as a rigid rule that cannot be broken, and I have seen mother-and-child portraits executed in dark values that are full of tenderness and feeling. I am simply trying to suggest one way in that you can deliberately orchestrate your values the better to express what you want to say. And in portraiture this is particularly important, since here the emphasis is on the expression of personality. Everything about the painting should be geared to making the

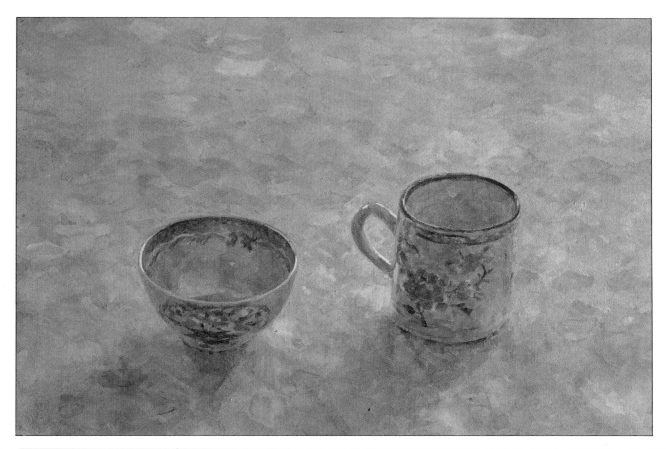

viewer aware of the sitter's character, and value and color will have a major influence on this.

Landscapes, of course, offer plenty of opportunities for high-key painting. The most obvious examples might be a snow scene on a sunny day; or a river that sparkles with light from the setting sun; or a landscape in fall, with the sun breaking through a pale mist and clothing everything in a silvery haze. Once again, the trick is to deliberately emphasize the lightness and brightness of the scene – to paint it lighter and brighter than it actually appears if necessary – in order to make a more forceful statement about your emotional response to the fleeting effects of light.

In still life painting, too, you can create a soft, romantic mood with pale values. Choose pretty, delicate objects – a jar of wild flowers perhaps, or pale china teacups – and arrange them on a windowsill with soft, diffused light coming through the window. Remember to keep the shadows soft and luminous, in keeping with the high-key effect.

Chinese Cup and Coffee Can by Jacqueline Rizvi, watercolor *left*. Pale values and high-key colors give this exquisite still life a delicate, airy feel, in keeping with the nature of the subject.

Watching Gulls by Lucy Willis, watercolor *above*. In contrast to the romantic mood of Jacqueline Rizvi's still life, the mood of this high-key painting is one of exuberance.

MIDDLE-KEY PAINTINGS

MID-VALUES FOR HARMONY

The vast majority of paintings fall into the middle-key range, in which neither extreme lights nor extreme darks predominate. When handled skillfully, a painting consisting mainly of middle values creates a subtle and harmonious image with a quiet, contemplative mood, as in Ellen Thesleff's portrait below. However, while closely related values may be harmonious, a middle-key painting is in danger of emerging flat, bland and lifeless unless it contains some positive contrasts, so try to introduce a few telling lights or rich darks into the scheme to give it more "snap".

Give careful thought also to the choice of colors in a middle-key painting. Since you are sacrificing the dramatic possibilities of *chiaroscuro* (light/dark contrast) it is vital that the image is exciting in terms of color. By choosing colors that are similar in value but contrasting in temperature or intensity, you will create a picture that is both harmonious and vibrant.

The Violin Player, by Ellen Thesleff, 1896 *above*. Everything about this painting is harmonious, simple and pure, in keeping with the introspective mood of the sitter.

Flowers from Monica by Diana Armfield, oil on board *left*. The bright colors of summer flowers are shown to best advantage against a neutral, mid-key background.

Low Tide, Marazion by Ken Howard, oil on board *below*. Notice how the three spots of red in this beach scene stand out against the neutral values.

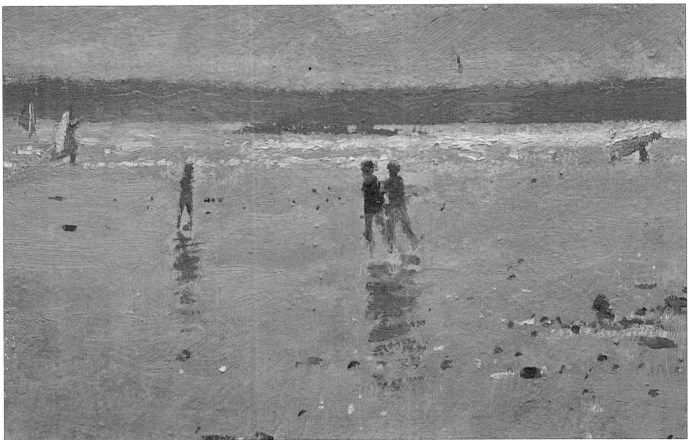

LOW-KEY PAINTINGS

DARK VALUES FOR DRAMA

As we have seen, a low-key painting is one that is predominantly dark in value, and such paintings create a very different mood from that of high-key ones.

In our subconscious minds, darkness is associated with night, which in turn we associate with mystery, suspense, and emotions such as sadness, fear and loneliness. Dark values can also create a feeling of strength and calm. By choosing your subject carefully and using colors in the mid to the dark value range, you can use the psychological effect of darkness and shadow to create exciting, dramatic images.

The examples shown on these pages demonstrate the powerful impact low-key paintings can have, both visually and emotionally. The appeal of such paintings lies in the air of mystery they convey, and humans have a strong fascination for the mysterious and the unexplained – as all good filmmakers know. After all, doesn't the figure lurking in the shadows strike us with far more terror than seeing the monster face to face?

In the same way, the most memorable paintings are always those that leave just a little to the imagination of the viewer. The portraits that Rembrandt painted are a classic example of this. Rembrandt knew how to use shadow as a veil, softening harsh outlines and creating a subtle atmosphere around the subject. His figures, softly lit, emerge from the shadows and yet seem a part of them. We are mesmerized, and the image continues to haunt us long after we first saw it.

Of course Rembrandt was a great master, and his technical skill with paint was astounding. But don't let that inhibit you: simply study Rembrandt's paintings (or reproductions of them in books) so as to absorb the mood they convey, and then see how you can create that mood through your own style of painting.

Never underestimate the value of *the power to suggest.* When we first start painting, we strive to render everything as clearly as possible in the mistaken belief that clarity equals realism. The result, of course, is that the subject ends up looking flat and two-dimensional, more like a cartoon than a painting. With more experience, we learn how to soften an edge here, darken a value there, and skillfully blend one area into another, in the interests of creating a picture that breathes and has life.

CHOOSING YOUR SUBJECT

As with high-key paintings, it's important that your subject is suited to the low-key approach. A portrait of a child, for example, would not generally be a suitable choice; but portraits of men – particularly older men – benefit from the use of low-key lighting that emphasizes rugged features. Low-key portraits of women work equally well, conveying a sense of mystery and introspection.

A still life of inanimate objects doesn't necessarily suggest a particular mood; it's up to you to create one. Try placing your still life against a dark background, lit by a small light source placed to one side of the group. This will create intriguing highlights and shadows, lending a subtle atmosphere and a mood of intimacy.

Outdoors, the low-key mood is more difficult to achieve because you have no control over the lighting. But landscape artists can take advantage of weather effects that create dramatic pictures; even the most ordinary scene is transformed when a storm threatens, or when dusk approaches and everything is wrapped in shadow. Or you could try painting a woodland scene, with shafts of pale sunlight breaking through the gloom.

Cat on a Chair by Lucy Willis, watercolor *opposite page.* A low key painting doesn't have to be somber. In this charming study of a cat on a chair, backlighting throws the subject into near-silhouette and creates interesting positive and negative shapes.

Sheep in the Snow by Diana Armfield, oil on canvas *left.* This painting conveys the stark mood of a bitterly cold winter's day. Notice how dark in value the snow is, particularly in the foreground where the shadows are a cool blue.

MOOD IN LANDSCAPES

HOW LIGHT AFFECTS MOOD

In a landscape subject, one of the most important elements to consider is light, because light affects both the values and colors of a picture, and both have a significant effect on mood. Claude Monet put it beautifully when he said: "For me, a landscape does not exist in its own right, since its appearance changes at every moment; but the surrounding atmosphere brings it to life – the air and the light, which vary continually."

Monet became so fascinated by the effects of light and color that he would happily return again and again to the same scene, painting it at different times of the day and in all seasons. Making a series of paintings of the same subject over a period of time is certainly an exercise worth trying, because it demonstrates how even quite small changes in the lighting can alter the balance of values in a picture, and therefore alter the mood it conveys. For example, a seascape viewed at midday might look flat and uninteresting because the light is very even and there is little contrast in values. But a few hours later, as the sun is going down, the luminous values of the evening sky contrast with the cool blue values of the sea and the land, creating a subtle and evocative image.

The seasons, too, offer splendid opportunities to explore the magic of light on the landscape. In winter, bleakness, silence and isolation can provide strong mood-themes, as when the branches of bare trees create dramatic patterns of light and

dark against the sky. Then again, the same scene is transformed by the sparkling light of a bright frosty morning; this time you might choose a limited range of light values with which to capture the bright, high-key mood. A snow-covered landscape on a dull day creates bold patterns of light and dark and there's also an interesting reversal of values as the sky, for once, appears darker than the land, creating a bleak, wintry feeling.

Viewpoint and composition are important elements in creating mood. The brooding atmosphere of an approaching storm is made more dramatic by placing the horizon line very low so as to place emphasis on the sky. On a sunny day you could try positioning your easel so that much of the view is in shadow except for one telling, sunlit spot. This will create a more dramatic and unusual picture than if the subject were evenly lit.

USING LIMITED TONES

To capture a fleeting mood successfully, it is best to restrict yourself to a limited number of values. Light, by its very nature, is elusive and ever-changing, and often there just isn't time to worry about the finer points – you have to sacrifice details and concentrate on capturing the essentials. With a particularly complex lighting effect, I often make a few simple monochrome sketches in watercolor, using only five values,

Looking Toward Colley Hill by David Hutter, watercolor *left*. The full drama of rolling storm clouds is captured in this exciting and unusual composition, in which the dark shape formed by the clouds is echoed in the landscape.

Beach Boats by Lucy Willis, watercolor *opposite, above*. This painting emanates a bracing, seaside atmosphere. A sprinkling of dark values helps to accentuate the crisp, bright light that fills the scene.

Chateau de la Motte by David Hutter, watercolor *opposite, below*. This painting captures the eerie light that occurs when sunlight slices through a gap in storm clouds and spotlights parts of the landscape, creating a dramatic reversal of the normal pattern of dark land against light sky.

and these give me enough information about the mood of the scene to be able to create a full-scale painting when I get back to the studio. This method has much to recommend it, in fact, because it forces you to work from memory when recording the details of form and color. Memory is selective – it "edits out" most of the superfluous details, leaving you with a clear recollection of the elements that most impressed you at first sight. This process of distillation is vital to the success of a picture, because your aim, after all, is to communicate to the viewer the same thrill that you felt – the thrill of the first impression, uncluttered by distracting details.

Even when I make a full-scale painting based on my sketches, I still try to keep to a limited range of values, because the fewer the values, the more forceful the statement. Remember that as an artist you are in control – you're free to use the subject as a starting point, and to try to express your ideas and feelings about it, rather than slavishly copying everything that's in front of you.

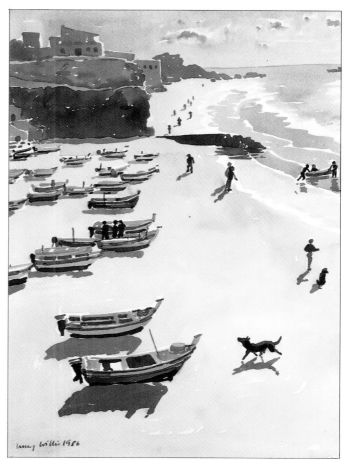

The Grand Canal, September Evening
by Ken Howard, watercolor and
gouache *above*. This painting captures
that magical time of day, just before the
sun sinks, when the sky takes on a
luminous aspect and the values of the
land are reduced to pale, shadowy
forms. The sparkling path of sunlight
on the water adds a palpable sense of
atmosphere and light.

The Auvergne by Moira Clinch,
watercolor *right*. Strong contrasts
between warm and cool color and light
and dark values lend a vibrant mood to
this sunny landscape in southern
France.

Project: In the mood

Following the example of the French artist Claude Monet, make a series of drawings or paintings of the same scene at different times of the day or under different weather conditions. Choose a location that's convenient to get to – your own backyard might be suitable – so that you can return to it quickly when the lighting conditions change.

Notice the different moods created as the amount, direction and color of the light changes. Use the expressive effects of tonal key to capture these different moods, as in the examples below.

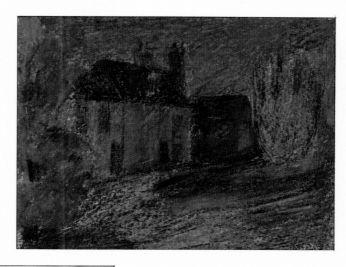

This sketch in oil pastels *above* uses dark, low-key values to create the somber, slightly threatening mood of a stormy day.

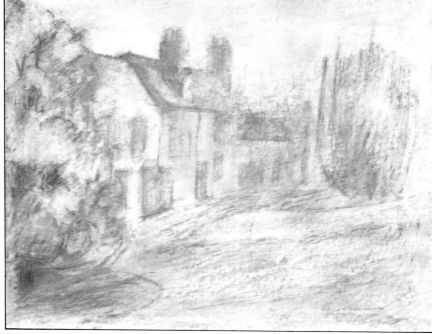

The same scene as before *above*, this time sketched on a bright, sunny morning. The artist has deliberately keyed his colors very high in order to capture the fresh sparkle of spring.

Self-critique

◆ Did you use broken brushstrokes for a more vibrant color effect?

◆ Did you succeed in achieving a harmony of color and value in each painting?

◆ Does each of your paintings convey a different mood?

MOOD IN INTERIORS

CAPTURING INTIMATE ATMOSPHERES

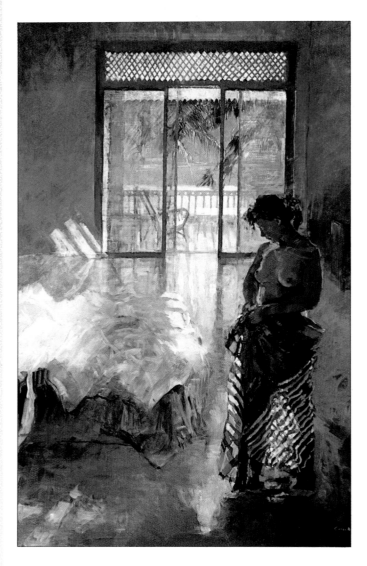

Tanjong Jara by Jane Corsellis, oil on canvas, 60in×40in *above*. This painting is strongly suggestive of the languid atmosphere of an afternoon in the tropics. The contrast between the cool, dark interior and the brilliant sunlight reflecting off the floor is stunning. The main value structure of the composition is balanced and geometrical, creating a sense of restful calm, broken only by the dancing pattern of light on the bedclothes.

Domestic interiors are often not seen as suitable painting subjects by beginners, perhaps because they are so much a part of everday life that it's easy to take them for granted. This is a pity, since interior scenes offer marvellous opportunities for creating unusual and exciting tonal compositions. Whether illuminated by natural daylight or artificial light, the closed environment of a room is rich with luminous values and soft, deep shadows that create a calm and tranquil atmosphere.

Interiors offer one distinct advantage over landscapes in that you can control both the compositional arrangement of the subject and, to a great extent, the lighting, so as to express what you want to say in your picture. The following are just some of the ideas worth considering:

◆ A darkened room with an open door in the background that offers a tantalizing glimpse of a scene beyond. The scene might be part of a sunlit landscape, or another room that is brightly lit; this will give you an opportunity to explore the dramatic contrast of light and dark values and warm and cool colors.

◆ An interior at evening, lit only by a table lamp that sheds a soft pool of light in an otherwise shadowy room. This sets up an intimate, low-key mood.

◆ Sunlight filtering through thin curtains that bathes the room in diffused light that lends a still, timeless atmosphere.

◆ To create a mysterious and evocative mood, include a shadowy figure, perhaps sitting at the fireside or reading by a lamp.

Before you begin to paint it's a good idea to make value sketches of the room from different viewpoints, until you find the composition that appeals to you. Observe how and where the light falls. Do the shadows and highlights create interesting patterns? Is the main area of light positioned where you want the center of interest to be? Is there a lively interplay of shapes and angles formed by the walls, floors, windows and furniture? All these things must be carefully considered; if necessary, rearrange, add or subtract objects until you get the effect you want. This is part of the process of learning to select from what you see in order to amplify what you want your painting to say.

Hoya in the Window by Lucy Willis, watercolor *above*. Another scene, this time with a much more high-key mood. The composition consists of a "frame within a frame". The warm greens of the garden, seen through the window, are surrounded and emphasized by the cool blues of the interior wall. Little slivers of bare white paper activate the painting and give an impression of sparkling light.

MOOD IN PORTRAITS

GETTING THE BEST FROM LIGHTING

Painting a portrait involves much more than simply achieving a likeness. Your painting should also say something about the character and personality of the sitter, an emotional quality that the viewer can empathize with. In this respect, the amount, quality and direction of the light will have an influence on the impression you wish to convey. As in a landscape, lighting affects the values and colors in the subject, which in turn convey a particular atmosphere and sense of place and time. For example, bright sunlight creates strong contrasts that convey energy and light-heartedness, whereas low lighting creates dark, somber values that convey an air of mystery and introspection.

You can also play two sources of light on the subject: the cool, weak daylight coming in from a window and the stronger, warmer light of a lamp. This creates a range of warm and cool colors that give a special luminosity and atmosphere to the portrait.

So before you start painting a portrait, first decide what kind of mood you wish to convey and arrange the lighting accordingly. Even if you don't have a proper studio, this shouldn't be too difficult; all you need is enough space to work in and a couple of lights with adjustable stands. The portrait paintings that follow demonstrate how to use specific lighting arrangements to create a range of very different moods.

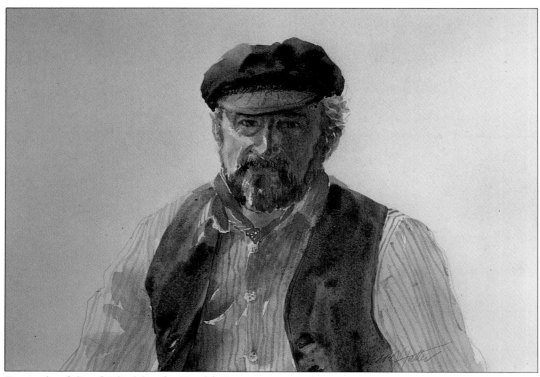

Portrait of Geof Kitching by David Hutter, watercolor.

Three-quarter lighting is so called because it falls on about three quarters of the face. This is the most popular type of lighting for most subjects, but is especially good for portraits, since not only does it give a strong impression of volume and surface texture, it also creates a satisfying range of tonal variations that give life and vitality to a portrait. If your sitter has strong features or a dynamic personality, use three-quarter lighting to emphasize these qualities.

In planning the portrait, consider whether you want to view the sitter from the shadow side or the light side. Facing the sitter's shadow side is best for expressing strong character; facing the light side creates a softer, more subtle effect. It's also worth experimenting with the angle and height of the lamp to see how this affects the shadows and highlights. Watch particularly for the shadow cast by the nose – a strong shadow reaching right down to the mouth can create a rather unattractive effect.

Portrait of Andrew Uter by David Hutter, watercolor.

Side lighting is another type of lighting popular with portrait painters. This time the face is lit directly from one side, leaving the other side in shadow. The strong contrast between light and shadow creates a sense of drama and tension in a low-key portrait, but care must be taken that the effect is not too theatrical. To soften the values slightly on the shadow side, use a white or reflective board to create "fill in" light in the shadow area. This also creates subtle reflected lights in the hair that prevent it from looking "dead."

Experiment with the colors, perhaps using cool ones on the shadow side and warm ones on the lit side to emphasize the contrast, and add carefully placed highlights on the brow, nose and chin.

Rembrandt lighting is a moody, dramatic lighting effect – named after the great Dutch master, who used it in many of his portraits. Here a small concentrated light source is positioned to one side so that the light falls at a sharp angle. This creates a spotlight effect, in which the sitter is revealed in dramatic contrast against a dark, shadowy background. Because the angle of the light is so sharp, it casts deep shadows into the eye sockets and plunges the lower part of the face into near-darkness. If handled well, this type of lighting lends a mysterious, enigmatic mood to a portrait, but obviously it is only suitable for some subjects.

Sue by the Reading Light by Doug Dawson, pastel, 15in × 16in.

Melanie at Oriel by Ken Howard, oil on canvas.

The near-silhouette effect created by placing the sitter in front of a soft, diffused light source is known as **contre jour,** which means "against the light". This creates a soft halo of light around the subject, while the facial features are almost lost in shadow. The effect is soft and mysterious, with a wonderful depth and richness of tone. If you're lucky, a small amount of light coming from slightly to one side will illuminate just a few telling edges of the subject – an effect known as "edge light" or "rim light" – adding even greater luminosity to the picture.

For a contre-jour portrait, the sitter should be placed at an angle to a window so that the face is seen in profile or semi-profile. The light should be weak or diffused; if necessary hang a lace curtain at the window to soften the effect of bright sunlight. If the silhouette looks too flat, try placing a reflective board opposite the window to bounce some light back onto the face.

USING SHADOWS CREATIVELY

INTENSIFYING MOOD WITH SHADOWS

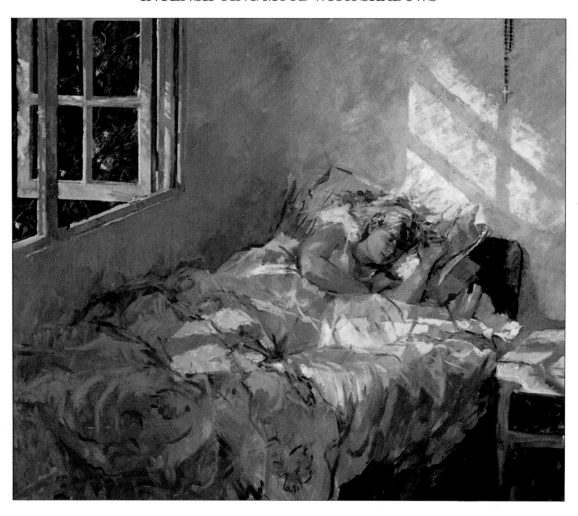

As a child I used to love lying in front of the living room fire on winter evenings and watch as the light from the flickering flames sent huge, liquid shadows leaping and dancing around the walls of the room. The shadows of chairs, teacups and potted plants, distorted and elongated, turned into fairies and witches and monsters in my still-fertile imagination.

Film-makers have always known how to use the dramatic potential of shadows to intensify the emotional effect of a scene. We've all gripped our seats while watching a thriller in which someone is being followed down a dimly lit street; we don't get to see the mysterious follower – only his shadow cast on the pavement – and this makes our imagination begin to work overtime. Somehow, being able to see only the shadow heightens the tension and has a far more menacing effect than if the identity of the man were revealed.

The same power of suggestion can be used to great effect in a painting, turning an ordinary image into one that's arresting, mysterious and evocative. Rembrandt achieved powerful dramatic moods through his use of deep, luminous shadows that enveloped most of the subject, just leaving a telling highlight here and there. Salvador Dali (b. 1904) and Giorgio de'Chirico (1888-1978) used very long or distorted shadows to accentuate the timeless, dreamlike atmosphere in their Surrealist paintings. The American painter Edward Hopper (1882-1967) painted people isolated within stark interiors or on deserted streets, and once again cast shadows are used to heighten the sense of loneliness and alienation.

But shadows are not always dramatic or threatening; they can also introduce beauty and poetry to a painting. Most landscape painters prefer to work in the early morning or late afternoon, when the sun is at a low angle to the earth and trees

and buildings cast long, descriptive shadows. My own favorite painting time is late afternoon on a sunny day in fall, when everything is bathed in a soft, golden light and the lengthening shadows lend a magical air of calm and stillness to the scene.

When a cast shadow travels across another object that lies in its path, that object becomes much more interesting to look at. In Jane Corsellis's painting (opposite), see how the shadows cast by the window frame travel across the contours of the bedding and the figure in a flowing, liquid pattern that transforms this everyday scene into a compelling picture. In addition to describing three-dimensional form, the graphic lines of the shadows offer an interesting paradox: unconsciously we shift back and forth between seeing the shadows as a descriptive element and as a purely abstract pattern. In this way our imagination is fueled and we play an active part in the work.

Carry a sketchbook with you whenever you can and make visual notes of any interesting shadow patterns you come across, such as those cast by a tree, or a wrought-iron gate, or the dappled shadows of trees and plants on a garden path. Indoors you can experiment by moving a lamp around the room, shining it on objects from different heights and angles to see what kind of shadows it creates (adjustable desk lamps are great for this).

Sara Asleep by Jane Corsellis, oil on canvas, 36in×38in *opposite page.* This painting is positively alive with light. The highlights and shadows cast by the window travel over the contours of the sleeping figure and the bedclothes in a flowing, liquid pattern. The mood is one of warmth, relaxation and intimacy.

The Inn Courtyard by Roy Herrick, oil on canvas *above.* Even a corner of your own backyard can be transformed by the magic of light. Here the sun filters down through the leaves of the tree, casting a lace-like pattern of light and shadow around the walls and across the pathway.

STILL LIFE ON A WINDOWSILL

This picture was painted on a spring morning, which the weathermen had promised would brighten and get warmer around lunch time, so the artist was in fairly optimistic mood facing his still life of wine and fresh fruit on the window's edge.

The view out of the window took in some fairly blank buildings, but also an expanse of garden whose grass was of that peculiarly intense green of the very freshest growth of spring. The sky was gray but the clouds were high and thin and the whole prospect had a feeling of air and light, space and the promise of better things.

1 My first step was to fix the objects firmly in space with a fairly accurate drawing in carbon pencil. Some rearrangement of the buildings gives more interest at the back of the picture, and I've uprooted and moved some of the trees for the sake of better compositional balance.

The first color application is in the form of watercolor washes of Hooker's green, yellow ocher and ultramarine blue for the sky and the tones of the cloth, fruit, window frame and grass. This establishes the lightest tonal values. The sky and parts of the cloth and window will not be further worked over, but allowed to shine up through the overlaid strokes of pastel color that follow.

I've used watercolor for three reasons. The first is that successive layers of pastel can fill up the grain of the paper quickly, clogging the surface and making it difficult to retain the freshness of color required for a delicate subject such as this one. By using watercolor in the initial stages, I can build up a lot of pastel color on top of it with fewer layers of pastel. The other reason is that watercolor's transparent effect is perfect for rendering the luminosity of the sky; a pastel sky can sometimes tend toward a heavy, unreal appearance – at any rate, when I try to paint one! The third reason is that, quite simply, pastel's dense, chalky appearance looks very attractive in juxtaposition to a delicate watercolor wash.

1

2 Still using watercolor, I block in the mauves of the window frame and the shadows in the cloth. This gives an idea of the cool, muted color values of the interior, which contrast with the warm, intense colors outside the window.

Now I'm ready to start overpainting with pastel, and I start by dotting in the dark windows of the building and making hatched strokes for the grass.

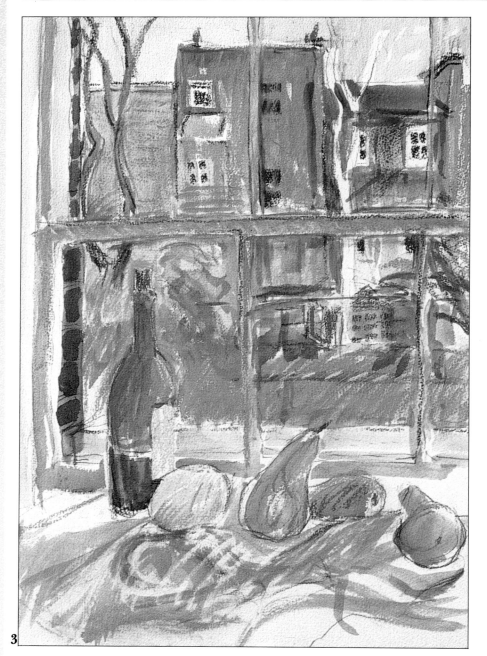

3 I start to define details and textures with hatched and scribbled strokes of olive green and umber. The overall tone is kept quite light to give an airy feel to the painting, but the color values are cool to give the atmosphere of a slightly overcast spring day. Notice how the foreground cloth echoes the mauves and lilacs of the window frame, lending a harmony and unity to the color composition.

Instead of working with solid masses of color, I'm using loose strokes of broken color, in the manner of the French Impressionists. This gives a vibrant, scintillating quality to the picture that suggests the play of light on the objects. It also lends inherent movement to the static shapes of the still-life group.

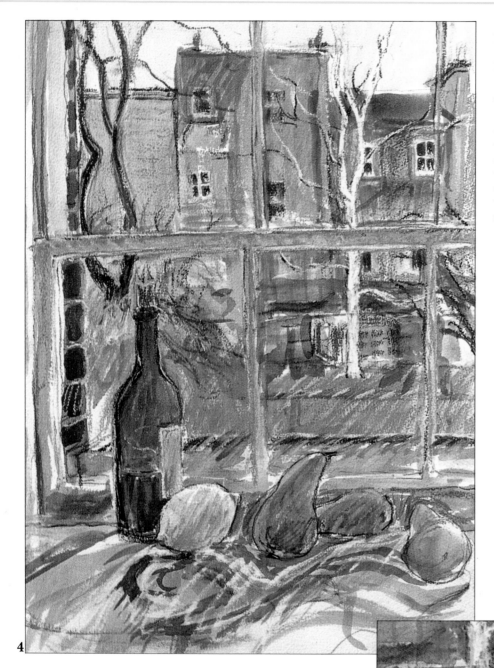

4 Next the darker values of the building, the bottle and the fruit are established, building up the colors in layers of olive green, pale turquoise, mauve and ultramarine. I work backward and forward, from foreground to background, which helps to unify the composition. I also like to weave similar colors throughout the composition, which again helps to tie things together. For instance, the same olive green is used for the trunks of the trees, the shadow tone of the lemon, and on the buildings.

In this detail of the grass you can see where the pale green watercolor wash glows up through the darker green strokes and creates a vibrant color effect.

This detail shows how layers of hatched strokes are used to build up form and color in the fruit. For the lemon I've used pale lemon-yellow, yellow green, olive green and traces of pale turquoise. The pears have their cool olive-greens warmed by strokes of pink umber, with highlights of a pale ice-green *right*.

Here you can see how the original watercolor washes have been left showing through on the buildings, forming a textural contrast with the grittiness of the pastel strokes *left*.

5 The whole scene *right* has been freely rendered to give the feeling of dappled light. This is a high-key painting, in which the effect of lightness and gaiety is enhanced by the use of consistently light values and bright colors, with the minimum of contrast. I've made extensive use of hatched strokes, both to build up areas of tone and to activate the picture surface by leading the eye through and around the composition.

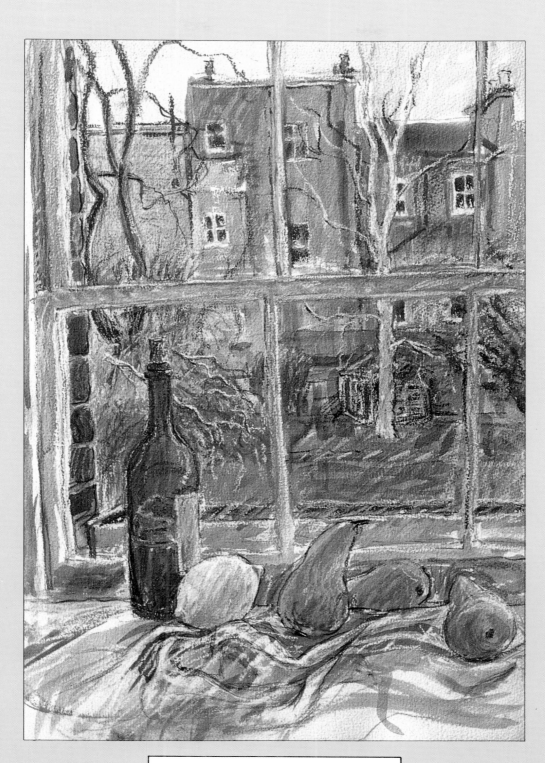

STILL LIFE ON A WINDOWSILL

CHAPTER

·8·

TECHNIQUES AND METHODS

I have kept this section on techniques till last because this book is primarily about training your eye to see things and interpret them in a way that is personal to you. All too often, technique becomes a crutch that the inexperienced painter leans on – but technique alone is a poor substitute for sensitivity, observation and feeling.

On the other hand, a sound knowledge of the craft of painting, when coupled with an enquiring approach to the subject, will certainly help you along the path to greater freedom of expression in your work. In this chapter I have included techniques like hatching, cross-hatching and line and wash, for example, because I believe the expressive beauty of these traditional techniques is unmatched in capturing the play of light and shadow on a subject.

The time-honored method of laying in a toned, or tinted, ground prior to painting in oils enables artists to judge the relative tonal values of their colors accurately as well as providing a unifying element in the overall design. For the pastelist and the watercolorist, toned papers play a similar role, and I will be discussing all these in detail.

TONED GROUNDS IN OIL

HARMONIZING WITH BACKGROUND COLOR

Most artists, at some time or other, have fallen prey to an attack of "white fright." Somehow it's difficult to get started – the canvas seems to stare accusingly as if to say "how dare you spoil my pristine whiteness." Hesitantly you start applying your colors, but pretty soon it all starts to look wrong – the colors and values just don't seem to hang together well.

The problem is that the cold whiteness of the canvas gives you a false "reading" of your colors and values, especially in the beginning stages when you've nothing to relate them to. The way to avoid these kinds of problems is by working on a toned ground. By covering your canvas with a flat or freely applied wash of some neutral color, you immediately create a more sympathetic surface on which to work. In addition, a toned ground helps you to judge the relative values and intensities of your colors more accurately, because it gives you an idea of how they will look when surrounded by other colors. Unless you're an experienced painter, it's best to avoid working directly onto a white ground, because it can lead to confu-

sion. A color like red, for instance, may look quite dark when applied to a white canvas; but as the painting progresses that same red will be surrounded by other colors, and suddenly it looks much lighter.

Another advantage of using a toned ground is that its color can help to unify the overall color scheme of the painting if small areas are allowed to show through the overpainting. You can even choose a specific color for the toned ground and allow it to dominate the whole painting, as Diana Armfield has done in her painting of a landscape (below).

CHOOSING THE GROUND COLOR

Traditionally, the ground color is chosen to provide a unifying middle value between the lightest and the darkest colors in the painting. If you're painting a cloudy sky, for example, a dilute wash of burnt sienna will provide a subtle middle value that ties together the shadows and the highlights in the clouds. Alternatively, you could choose a ground color that provides a quiet contrast to the overall color scheme of the painting. The

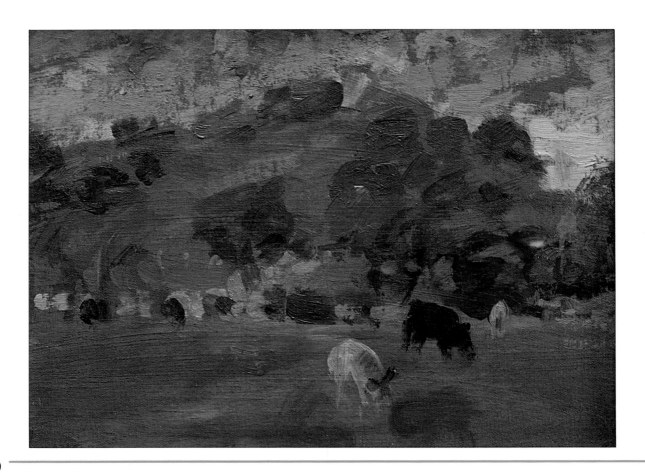

classic example of this is the use of a soft green like terre verte as a ground when painting figures; the warm values of the flesh appear more luminous when subtle hints of cool green are allowed to show through in the shadow areas. And in a stormy seascape, a ground of red oxide will help to unify the grays of the sky and the sea, while at the same time making those grays look more interesting and colorful.

The golden rule when making toned grounds, though, is subtlety. The ground color should complement, not compete with, the colors in the overpainting. Always stick to soft, earthy colors and use them thinly.

APPLYING THE GROUND

Depending on your requirements, you can choose either a transparent or an opaque ground. With a transparent ground (known as an *imprimatura*) the paint is heavily diluted with turpentine (or mineral spirit) and applied as a thin wash. The advantage of a transparent ground is that it allows you to assess the values of the succeeding colors accurately, while at the same time retaining their luminosity. This is because light is allowed to get through to the white canvas and bounce back up through the colors.

However, thin washes of color will start to fade eventually, so if you wish to leave large areas of the ground color exposed, forming an integral part of the painting, you are better off with an opaque ground. To make an opaque ground, dilute the color with turpentine and a little linseed oil, and add some titanium white to the color to soften it.

Always make sure the toned ground is completely dry before you paint over it. An opaque ground can take anything up to 48 hours to dry, a transparent ground somewhat less. A quicker method is to use acrylic paint to tint the canvas. This dries in minutes, and can then be overpainted in oils in the normal way (oils can be used over acrylics, but not vice versa).

Llanfur by Diana Armfield, oil on canvas *left*. This little oil sketch is brilliantly economical in its evocation of place and atmosphere. The warm, earthy color of the toned ground acts as a unifying element, tying together the sky, the hill and the field. In musical terms, it is like the rich, mellow sound of the bass, while the energetic brushstrokes are like the string section – light and melodious: the two together create perfect harmony.

A toned ground is usually of a neutral gray or earth color *above*, softened with a little flake white and diluted to a liquid consistency. Here the artist is using a rag to distribute the paint over the canvas, rubbing it well into the grain.

For a transparent ground *right*, the paint should have a liquid consistency. If you are using oil paint, dilute it with copal varnish. Acrylic paint can be diluted with water or acrylic medium. Use a large brush and apply the paint thinly so that the white gesso or canvas shines through.

MONOCHROME UNDERPAINTING

A CLASSIC TECHNIQUE

As we've discovered in the preceding pages, working on a toned ground helps us to solve the problem of judging values and colors accurately. For many painters, the next stage in the painting process is an underpainting – the blocking in of the main shapes and values of the subject in monochrome, prior to the addition of the finished color.

The purpose of making an underpainting is to establish the composition and the value structure of the painting at the outset, thus giving you an accurate idea of what the final result will look like. In other words, it serves the same purpose as a monochrome sketch, except that in this case it will become an integral part of the finished painting.

The advantages of making an underpainting are numerous. Firstly, it takes much of the guesswork out of the painting process and allows you to proceed with greater confidence. The underpainting provides a kind of "blueprint" that you can use as a guide to the relative values of the colors that you apply on top of it. With the composition and the value structure firmly established at the outset, you are free to concentrate on color and texture in the later stages of the painting, because all the decisions about light, shade and modeling have already been made.

Secondly, any corrections and alterations to the composition can be made at the underpainting stage, once again leaving you free from worry in the later stages. With an underpainting, the paint is used very thinly, so alterations can be made simply by wiping the area with a rag soaked in turpentine and going over it again.

Finally, starting with an underpainting can add much to the sheer pleasure of painting. Instead of nervously throwing paint at the canvas and hoping it will all come together in the end, you'll experience the quiet satisfaction of watching your painting develop, slowly and surely, from a "skeleton" to a strong and unified image; the same satisfaction, in fact, that a sculptor or a woodcarver gets from starting with a rough-hewn shape and gradually working up to the finest details.

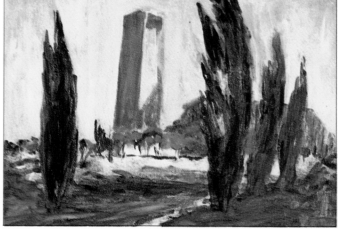

In this demonstration oil painting of a landscape in Italy, artist Laurence Wood explains how he uses a monochrome underpainting to establish the play of light on the scene.

1 I start by making an initial underdrawing in brown conté crayon, which I fix before painting starts. Using a mixture of Paynes gray and ultramarine, I apply a midtone all over the canvas. The paint is very thin and dilute, allowing the white primer to shine through and give a luminosity to the succeeding colors. While the paint is still wet, I wipe out the lightest values by soaking up the paint with a tissue.

2 When the first stage is dry, I block in the middle values with a mixture of Paynes gray and ultramarine. Then I add the darks, using ivory black and burnt umber. The paint is still dilute and transparent at this stage, allowing me to make alterations if necessary. The painting is left to dry for several hours.

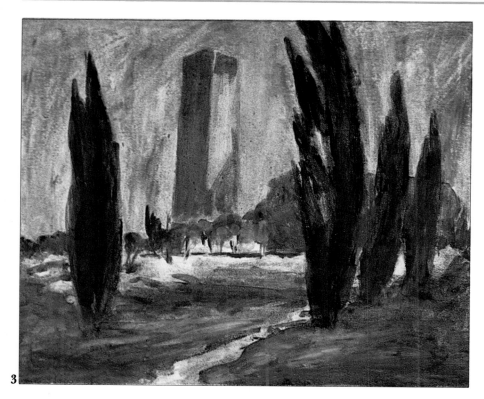

3 With the value pattern firmly established, I can go on to add color. I continue working with layers of transparent glazes, building up a depth and luminosity in the colors. More opaque paint is used to create dense areas of foliage that form a contrast with the transparent tones of the sky.

Tower on the Torcello, Venice by Laurence Wood, oil on canvas *below.* In the finished painting the monochrome underpainting is allowed to show through in places, and this helps to retain the freshness of the artist's first impression.

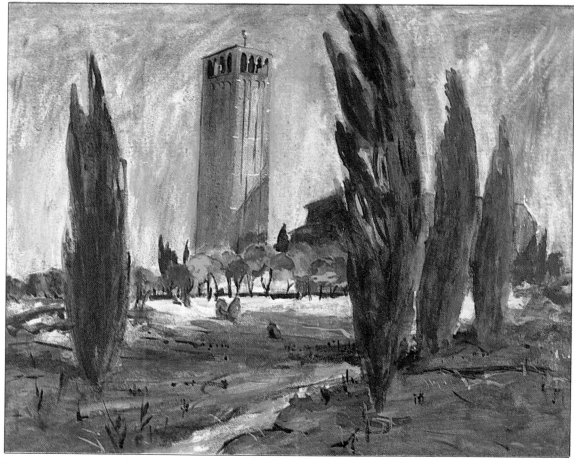

Toned Papers

COMPLEMENT YOUR SUBJECT

You may have noticed how few pastelists work on white paper. There are two reasons for this, the first being that the bright, intense hues of pastel are not shown to their best on white paper, appearing rather dark, whereas they seem to sparkle on a medium- or dark-tinted paper. Secondly, pastel is usually applied in swift, broken strokes that leave areas of the paper untouched, so it makes sense to choose a paper the color of which will contribute to the overall color scheme of the painting. You may, for example, want to select a paper that is similar in value or color to the subject and provides an overall middle value, so that all that's needed to complete the painting are the highlights and shadows. Alternatively, you could choose a light paper that would serve as the highlight areas, or a dark one that would serve as the shadow areas.

By allowing the color of the paper to play an integral part in the painting, you achieve two things: first, the paper's color becomes a unifying element, tying together the colors laid over it. Second, it means you can get away with putting fewer marks on the paper, and this gives an attractive freshness and spontaneity to the finished painting.

CHOOSING THE RIGHT PAPER

It is important to choose both the color and value of the paper carefully, because they have a direct effect on the way the pastel colors appear, particularly in the initial stages. But with such a wide range of colored papers available, how do you make the right choice?

With regard to color, first decide whether you want it to harmonize with the subject or to complement it. Then decide whether the color should be cool, warm or neutral. For example, a cool green paper acts as a perfect foil for the warm skin tones in a portrait; a warm blue-gray harmonizes well with the colors of a stormy sky and sea; a neutral gray lends a quiet balance to a study of brightly colored flowers.

Generally it's best to choose soft, muted colors in preference to bright, strong ones. The paper's color should play an unobtrusive part and not vie for attention with the colors of the drawing or painting.

Just as important as choosing the color of the paper is choosing its tonal value, and your choice will generally depend on how light or dark the subject itself is. Papers with a

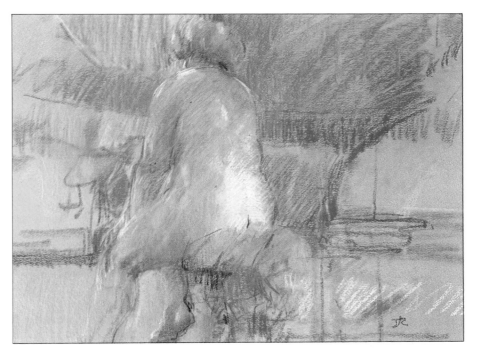

Nude by Tom Coates, pastel *left* . In this vibrant pastel sketch, the warm tonality of the paper shimmers through the overlying colors and ties the whole thing together.

middle value are the most popular choice, since being neither too dark nor too light they allow for subtle color harmonies and are easily adaptable to most subjects. They also allow you to establish both the light and dark areas of the painting early on, since both can be accurately gauged against the mid-tone of the paper.

Papers with a light tonal value will provide contrast in a predominantly dark painting or drawing, and will create light accents and highlights. Pale values and colors, however, generally don't show up well on a light paper.

Papers with a dark tonal value can be used with brightly colored subjects, or subjects in which strong contrasts are required. On the whole, though, dark papers, particularly black, are best avoided since they provide contrasts that are too strong, giving the painting an over-stated, unsubtle appearance.

TONING PAPERS BY HAND

The various paper manufacturers offer the pastelist a wide range of colors and tones to choose from, but even so there may be occasions when you prefer to tint your paper by hand. You may, for example, dislike the flat, even, mechanical tint of the paper and decide to introduce some variety with a partial covering of paint. A certain shade of blue may appear too cold and need to be warmed up with a thin wash of red. Or you may wish to leave large areas of the paper untouched, in which case a wash of color will help to protect it from any premature fading on exposure to the light.

Any dilute, water-based paint can be used to tint pastel paper. Watercolor, gouache or acrylic can be applied with a soft brush or sponge, or blown onto the paper with a spray dif-

fuser for a particularly delicate effect. Another favorite method is to save the broken ends of pastel sticks and crush them to a powder with a palette knife; a damp rag is then dipped into the powder and rubbed over the paper. When the paper is dry, any surplus powder is removed by tilting the board and tapping it sharply from the back.

Crushed leftovers of broken pastels can be rubbed into the paper for a soft, grainy effect *above*.

Seascape I by Jacqueline Rizvi, watercolor and gouache *left*. Purists may frown, but watercolor doesn't *have* to be used with white paper. For those artists who don't go into a dead faint at the idea of using body color for their whites, watercolor paper is available in shades of cream, blue, gray and brown (or you can tint your own white paper with a flat wash of watercolor). This seascape was painted on a mid-toned buff paper. You can see where its warm color shows through and contrasts with the cool blues of the sea and sky, imparting a pearly luminosity.

LINE AND WASH

"CREATING" SPONTANEITY

For drawings in pen and ink or watercolor, line and wash is an extremely expressive and attractive technique. Here we have two opposites – finely drawn lines and soft, fluid washes – working together in perfect harmony. The lines give structure and lively emphasis to the drawing, while the ink washes soften the effect of the strokes and suggest texture and value. Some of Rembrandt's most beautiful drawings were executed with this technique; with just a few brief lines and curving sweeps with an ink-loaded brush, he was able to capture the play of light on a figure with exquisite simplicity.

In the line and wash technique, outlines and details are indicated lightly with a pencil, brush, or pen and ink. Then a dilute wash of ink or watercolor, usually in monochrome, is applied over the lines, leaving areas of bare paper to serve as highlights. When the first wash is dry, further washes can be applied to darken the values where necessary. If you prefer, you can reverse the process, starting with the washes first and then putting in the lines and details on top.

Because of the inherent fluidity of the line and wash technique, it is perfect for portraying living, moving subjects: figures, animals, birds, flowers, trees and the like. Landscape artists, in particular, find it an invaluable method of making rapid sketches of the fleeting effects of light, or the movement of clouds. But it is also well suited to portraying inanimate objects such as buildings, because it breathes life and movement into a subject that might otherwise appear static.

The beauty of line and wash work lies in its sketchy, "unfinished" quality. Viewers usually find this much more attractive to look at than a tightly rendered drawing, because it allows them to use their creative imaginations to "fill in" the details for themselves. Never overwork a line and wash drawing – a few scribbled marks and simple, broad washes are often all that's necessary to convey everything you want to say.

In this drawing by Laurence Wood *above*, delicate lines and soft washes of tone combine to portray the simple grace of a long-stemmed rose.

With great dash and verve, Ian Ribbons uses scribbled lines and washes to capture not only the play of light but also a sense of life and movement *right*.

Sepia ink gives an attractive, mellow quality to line and wash drawings. In this view of Venice *below*, Maurice Armytage emphasizes the play of light on the beautiful buildings by leaving white paper to show through for the highlights.

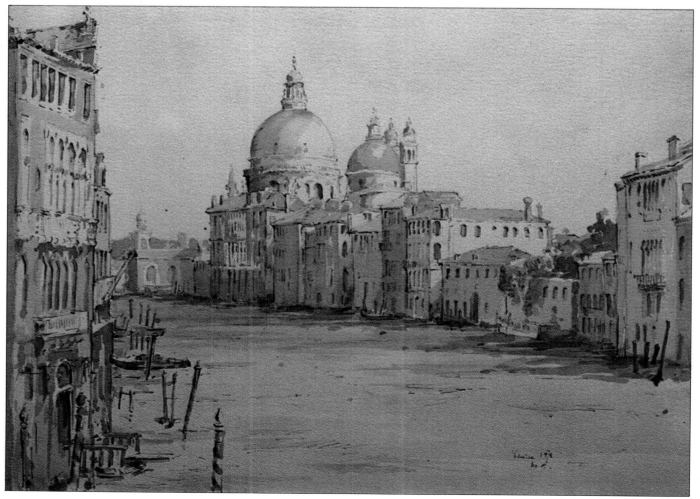

HATCHING AND CROSS-HATCHING

BUILDING UP VALUES

If you're working in a linear medium such as pen and ink, pencil or pastel, you can create a gradual build-up of values by using the techniques of hatching and cross-hatching. In hatching, an area of value or color is rendered by making a series of close, parallel strokes which appear to the eye as a solid tone. By varying the pressure on the stroke, and the width between strokes, considerable variations from light to dark can be achieved; the closer together the strokes the darker the tone will appear.

To deepen the tone even further, a second set of strokes can be added over the first in the opposite direction. This is called cross-hatching. If you want to build up a really dense, textural effect, you can add still more strokes in yet another direction; for example, vertical and horizontal strokes can be overlaid with diagonal ones. Hatching and cross-hatching demand a patient, methodical approach – you have to start with the lightest areas and gradually work up to the darkest ones so as to achieve an even gradation. Beware of making your strokes too mechanical and even, though; freely drawn lines look much more lively than lines that look as though they've been drawn with the aid of a ruler.

By reducing or increasing the density of cross-hatched lines, variations in tone from light to dark can be achieved. Experiment also with different color combinations; when two or more colors are worked over each other the effect is extremely vibrant *above*.

The textural depth of an area can be increased by juxtaposing small areas of cross-hatching that run in different directions *left*.

Richmond Park by Laurence Wood, colored pencil *above*. This landscape drawing is a good example of the complexity of color and value that can be achieved with hatching and crosshatching. The directional nature of the lines creates both movement and texture in the trees.

INDEX

CREDITS

p2 Pamela Kay, courtesy of Chris Beetles Ltd, St James's, London. **p8** Jane Corsellis, courtesy of The New Academy and Business Art Galleries, London. **p10** Jean-Baptiste-Siméon Chardin, courtesy of The Louvre, Paris (Photo: Bridgeman Art Library). **p11** Pamela Kay, courtesy of Chris Beetles Ltd, St James's, London. **p12** Vilhelm Hammershøi, courtesy of Aarhus Art Museum (Photo: Poul Pedersen, Aarhus). **p13** Bernard Dunstan, R.A. **p14** Edward Hopper, courtesy of Friends of American Art Collection, 1942.51, © 1987 Art Institute of Chicago. **p15** Walter Garver. **p16** Edward Wesson, courtesy of Chris Beetles Ltd, St James's London. **pp19-21** Laurence Wood. **p22** Photo: Teresa Linsley. **p23** Laurence Wood. **pp25-26** Charles Inge. **p27** Laurence Wood. **p28** Pamela Kay, courtesy of Chris Beetles Ltd, St James's, London. **p30** Charles Inge. **p31** (top) Joan Heston (collection of artist); (bottom) Roy Herrick. **p32-33** Laurence Wood. **p34** Charles Inge. **p35** (top right) Charles Inge. **pp36-41** Tom Coates. **p42** Pamela Kay, courtesy of Chris Beetles Ltd, St James's, London. **p45** Charles Inge. **p46** David Hutter. **p47** Charles Inge. **pp48-49** Charles Inge. **p51** David Hutter. **pp52-55** Tom Coates. **p56** Charles Harrington, courtesy of Chris Beetles Ltd, St James's, London. **p58** Clemente Gerez. **p59** Diana Armfield. **p60** Tom Coates. **p61** Charles Inge. **p62** Diana Armfield. **p63** David Hutter. **p64** Diana Armfield. **p65** (top) Ken Howard, A.R.A.; (bottom) Pamela Kay, courtesy of Chris Beetles Ltd, St James's, London. **p66** Pamela Kay, courtesy of Chris Beetles Ltd, St James's, London. **p67** Tom Coates. **pp68-69** Laurence Wood. **pp70-73** Roy Herrick. **p74** Roy Herrick. **p77** Laurence Wood; Photo: Nick Clark. **pp78-79** Charles Inge. **p80** (top) Gary Michael (collection of Richard Morgan); (bottom) Paul Millichip (private collection). **p81** Stan Perrott. **p82** Roy Herrick. **p83** Charles Inge. **p84** (top) Maurice Armytage; (bottom) Diana Armfield. **p85** (top) Raymond Leech; (bottom) Charles Longbotham. **p86** (top) Leslie Worth; (bottom) Lucy Willis, courtesy of Chris Beetles Ltd, St. James's, London. **p87** Laurence Wood. **p88** Laurence Wood. **p89** Christa Gaa. **p90** Andrew Macara, courtesy of The New Academy and Business Art Galleries, London. **p91** (top) Lucy Willis, courtesy of Chris Beetles Ltd, St James's, London; (bottom) Roy Herrick. **pp92-93** Charles Inge. **p94** Bert Wright. **p95** Laurence Wood. **pp96-99** Raymond Leech. **p100** L.A. Ring, courtesy of Statens Museum for Kunst, Copenhagen. **p102** Oliver Warman, courtesy of the Federation of British Artists. **p103** (top) Pamela Kay, courtesy of Chris Beetles Ltd, St James's, London; (bottom) Ken Howard, A.R.A. **p104** Jacqueline Rizvi. **p105** Lucy Willis, courtesy of Chris Beetles Ltd, St James's, London. **p106** Ellen Thesleff, courtesy of Ateneumin Taidemuseo, Helsinki. **p107** (top) Diana Armfield; (bottom) Ken Howard, A.R.A. **p108** Lucy Willis, courtesy of Chris Beetles Ltd, St James's, London. **p109** Diana Armfield. **p110** David Hutter. **p111** (top) Lucy Willis, courtesy of Chris Beetles Ltd, St James's, London; (bottom) David Hutter. **p112** (top) Ken Howard, A.R.A.; (bottom) Moira Clinch. **p113** Laurence Wood. **p114** Jane Corsellis, courtesy of The New Academy and Business Art Galleries, London. **p115** Lucy Willis, courtesy of Chris Beetles Ltd, St James's, London. **pp116-117** David Hutter. **p118** Doug Dawson. **p119** Ken Howard, A.R.A. **p120** Jane Corsellis, courtesy of the New Academy and Business Art Galleries, London. **p121** Roy Herrick. **pp122-127** Daniel Chatto. **p130** Diana Armfield. **pp132-133** Laurence Wood. **p134** Tom Coates. **p135** (bottom) Jacqueline Rizvi. **p136** Laurence Wood. **p137** (top) Ian Ribbons; (bottom) Maurice Armytage. **pp138-139** Laurence Wood.

Photograpy: Ian Howes, Joy Gregory and Rose Jones.